IMAGES
of Rail

ST. LOUIS GATEWAY RAIL
THE 1970s

On the cover: The last train to pull out of the St. Louis Union Station was headed by Amtrak locomotive No. 236 on November 1, 1978. Union Station, designed by architect Theodore Link and inspired by the medieval walled French city of Carcassone, once provided passenger service for 200 trains per day. It cost $6.5 million to build. When it opened in 1894, it was the largest passenger terminal in the country. At that time, St. Louis hoped to become the preeminent rail center of the American Midwest. The station features a large Tiffany stained-glass *Allegorical Window*, in which three women—New York, St. Louis, and San Francisco—sit together figuratively to assert this ambition, which would be thwarted by Chicago. By 1978, the station only serviced six trains per day. The huge castle with the train shed behind it stood vacant until 1985 when it reopened as an upscale shopping mall and hotel. (Courtesy of the St. Louis Globe-Democrat archives of the St. Louis Mercantile Library, University of Missouri-St. Louis.)

IMAGES
of Rail

ST. LOUIS GATEWAY RAIL
THE 1970s

Lesley Barker

Copyright © 2006 by Lesley Barker
ISBN 978-0-7385-4070-2

Published by Arcadia Publishing
Charleston, South Carolina

Printed in the United States of America

Library of Congress Catalog Card Number: 2006924916

For all general information contact Arcadia Publishing at:
Telephone 843-853-2070
Fax 843-853-0044
E-mail sales@arcadiapublishing.com
For customer service and orders:
Toll-Free 1-888-313-2665

Visit us on the Internet at www.arcadiapublishing.com

For Esther, Nancy, Audrey, Lottie, Colin, Alice, and Roger who are heirs of this rail legacy of their grandfather, John Findley Green Barker.

CONTENTS

Acknowledgments		6
Introduction		7
1.	Terminal Railroad Association and Manufacturer's Railway Company	11
2.	Major Railroads in the St. Louis Gateway	25
3.	Non-Railway-Owned Cars Seen in the St. Louis Gateway	115
Bibliography		127

ACKNOWLEDGMENTS

John Barker and I spent about 18 months together talking about trains in St. Louis while I created a visual and audio digital record of his *Representative Collection of Trains in St. Louis from 1900 to 1990*. His world is viewed through a railroad lens. Adding a painstaking attention to minute detail to an analytic scientific mind makes his work a valuable contribution to future historians and scholars. Even as a boy in 1942, John Barker roamed the railroad tracks, yards, and stations of Ann Arbor, Michigan, by bicycle, hoping to capture the large iron steam locomotives as well as the smaller hand-powered crew carts with his camera. Painstakingly he penned each location and the specifications of each train on the back of each print. It was a discipline and a pastime that he would continue for the next 50 years in St. Louis.

Not even he could have predicted that this passion for power would grow into a mammoth collection of accurately detailed HO-scale models, but it did. Today the collection, along with the more than 3,000 photographs of trains in and around St. Louis, about 450 train postcards, and assorted other magazines, books, and memorabilia, belongs to the John Barriger III Railroad Library of the St. Louis Mercantile Library at the University of Missouri-St. Louis. Unless otherwise noted, John Barker photographed the images in this book, often on his lunch breaks from his job at the McQuay Norris Corporation.

In addition to thanking John Barker, I am grateful for the time, help, and encouragement given during this project by Gregg Ames, curator of the John Barriger III Railroad Library of the St. Louis Mercantile Library, and to Miranda, Jesse, and Debbie who are also at the Mercantile Library. I am also grateful to author David Lossos, who introduced me to Arcadia Publishing, to my editor, Anna Wilson, and to my good friend, Sonny Ketcham, another railroad buff.

Introduction

To focus on just one decade of either the history of a certain city, St. Louis, which was founded in 1764, or of a specific industry, rail, which is itself nearly 200 years old, may seem a bit too narrow, especially when the city is the second largest rail center in the American Midwest. Our focus centers on trains in St. Louis in the 1970s. Why this particular decade? It was at the period of transition between when railroads dominated American freight and passenger traffic and when, thanks to the interstates and air travel, they were forced to consolidate into the mega-railroad conglomerates of today. This book is a pictorial overview of the railroads that served the St. Louis Gateway, and the non-railway corporations whose railroad rolling stock was seen in St. Louis during that 10-year period. To set the stage, it is useful to consider how the St. Louis-railroad relationship grew.

St. Louis changed as the railroads developed. Initially it seemed that the city would resist and even obstruct the railroads in its effort to retain a kind of hegemony over the Mississippi River steamboat traffic. Then, in an almost desperate quest to become the preeminent rail center of the American Midwest, St. Louis concentrated many resources on the development of its railroad industry, but finished in second place behind Chicago. The original spokesman for this goal was Sen. Thomas Hart Benton of Missouri who embraced Thomas Jefferson's Manifest Destiny as his own life's ambition. He articulated the need for a transcontinental railroad in a major speech at the 1849 railroad convention in St. Louis. The story of the way St. Louis has been impacted by the railroad is a fascinating one that has seldom been told. In essence, to chronicle the history of trains in St. Louis is to grind a lens through which the attitudes and priorities, which shape the city's culture and politics, can be brought into focus.

St. Louis, Missouri, is located at the intersection of the Mississippi and the Missouri Rivers. The River Des Peres forms part of the western border of the city and flows from and to the Mississippi River. At St. Louis, the Mississippi River bends toward the east to form a semicircular land mass. If you draw a straight line across the western side of the bend, the whole city fits within the enclosed land mass. For railfans, the St. Louis Gateway implies much more than just the city of St. Louis. The St. Louis Gateway includes all the railroad yards and trackage on both sides of the Mississippi River including East St. Louis, Illinois; Dupo, Illinois; Venice, Illinois; and St. Louis, Missouri. This complicates our picture because the railfan's concept of St. Louis is oblivious to the rivalries, jealousies, and loyalties of the various metropolises. There are only two organizations, other than the transportation agencies, the Regional Commerce and Growth Association and the East-West Coordinating Council, which conceive of St. Louis as a region that includes counties in both Missouri and Illinois.

The St. Louis city limits changed several times. The original city, which was laid out in 1764, included 64 plats on the ground, which is the modern Gateway Arch Riverfront and Laclede's Landing. By 1822, the west border was Seventh Street; the south border was Soulard; and the north border, east of Broadway, was Willow Street and west of Broadway, it was Carr Street. By 1841, the south border was Louisa Avenue, the north was Wright Street, and the west was extended to Eighteenth Street. Finally, the current boundaries were established so that the western limit is 500 feet west of McCausland/Skinker Avenue. St. Louis city does not belong to any Missouri county. It is surrounded and completely trapped between St. Louis County and the Mississippi River. Until trains could enter via the Eads Bridge, freight and passenger trains were forced to use the Wiggins Ferry to cross the Mississippi River at St. Louis. The railroads that were chartered east of the Mississippi River often did not have the authorization needed to operate on the west side even after the bridge was opened. This kept the Wiggins Ferry Company in the business of hauling trains across to where they could be coupled to trains that were bound further west.

When Baltimore and Ohio, in the east, began to lay track in 1829, St. Louis had become an American city with an international population and a reputation as a river city, which would make its next three decades known as the Golden Age of Steamboating. In 1830, Gen. Charles Gratiot of St. Louis commissioned Gen. Robert E. Lee to design the engineering project to clear the Mississippi River channel at St. Louis so that it would remain passable for large steamboats. The city's economic reliance on its river port clashed with the agenda of the earliest railroad developers. To build a railroad drawbridge over the river at St. Louis would have imposed an obstruction to steamboat traffic.

The Wiggins family ferry business was closely aligned with the Chouteau family–dominated steamboat business. St. Louis had become the busiest inland port in the United States, since 1817 when the first steamship, the *Zebulon Pike*, docked at the riverfront for the first time. By 1846, St. Louisans owned 67 of the 1,200 steamboats on the Mississippi. Other steamboats carried settlers west up the Missouri River to Kansas City, from which point they could progress still further west by wagon train. Obviously, the rivers seemed to be much more valuable to St. Louis's aristocracy than trains. These old, established French families had made their money from the river and, no doubt, they intended to continue to profit from it.

The Americans who settled in St. Louis in the 1830s, however, were determined to find another path to prosperity. One group of influential merchants understood that the railroad could be their ticket to affluence, especially as more and more of the west opened to settlers. They formed the St. Louis Chamber of Commerce in 1836. Many of these same men organized the Merchants Exchange in 1848. One was Daniel D. Page, the city's second mayor and a member of the original group that incorporated the Pacific Railroad in 1849. The city continued to invest in the river, spending $200,000 on wharf improvements around 1850, but it also gambled on the railroad, hedging its bets by investing $250,000 in Pacific Railroad stock. The railroad began construction in 1850.

Railroads require depots, freight warehouses, and yards. This prompted the design and construction of a new cultural monument, Union Station, the "largest railroad station in the world." (Grand Central Station in New York City was one-third its size.) The spire still stands guard over the European-inspired building, which is due west of the Gateway Arch on Market Street. There were 24 tracks at Union Station that could serve as many as 400 passenger trains daily. A tunnel connected Union Station to the main post office and to Cupples Station with its 18 freight houses. On November 1, 1978, Union Station closed to railroad traffic. (See the image on the cover of the last train to leave Union Station.) The building remains transfigured now as a huge upscale shopping mall complete with a posh hotel, an array of restaurants, a beer garden with a lake, and train tracks over which excursion trains run from time to time. The original stained-glass window, in which three women represent New York, St. Louis, and San Francisco, remains today in the balcony under the arch on the north wall of Union Station. This window continues to proclaim the city's aspirations to become the preeminent midwestern rail center

that would link the Atlantic and its access to Europe with the Pacific and its access to Asia, a proclamation that has not been silenced.

The St. Louis 1904 World's Fair was the next major event to stimulate and influence railroad developments in and out of the St. Louis Rail Gateway. According to Webster University's Professor Bob Corbett, one reason given for choosing Forest Park was "the location of the World's Fair upon Forest Park site would give direct connection to the Union Station of the double track of the St. Louis and San Francisco Railroad, the double track of the Missouri Pacific Railroad. . . . In addition to this, the St. Louis and San Francisco, Missouri Pacific, Wabash, and St. Louis, Kansas City & Colorado Railroad can deliver all passenger business outside the city direct to the World's Fair grounds."

The president of Terminal Railroad Association of St. Louis (TRRA), David Francis, served as the chairman of the St. Louis World's Fair. For him to have held the success of this fair as such a high personal priority indicates its value in the opinions of the St. Louis railroad moguls. David Francis went on to become mayor of St. Louis, governor of Missouri, cabinet member for Pres. Grover Cleveland, and United States ambassador to Russia. According to *St. Louis Commerce Magazine* (December 1999), he spent the four years prior to 1904 traveling to personally invite international government officials to visit St. Louis during the fair.

TRRA continued to be intimately involved in the implementation of architect Eero Saarinen's winning design plans for the Gateway Arch. Today the Gateway Arch stands at the edge of the Mississippi River just south of the Eads Bridge. Any of the engineering solutions proposed to enable the Gateway Arch to be built required changes in the location of the TRRA's tracks. The city government had its own interest in the development of the riverfront, as it still does today, and the federal government was heavily committed to finance and to oversee the project.

The demolition of the buildings on the site of the 1764 city of St. Louis to make room for the Gateway Arch began in 1939. Except for the Old Cathedral and the Old Courthouse building, all the area was razed. The bickering, interrupted first by World War II and next by the Korean War, was a four-way tug-of-war between Saarinen, the City of St. Louis, the TRRA, and the National Park Service. It took until 1968 for the Gateway Arch to be built and opened to the public.

More than just the Gateway Arch reconfigured the St. Louis riverfront during the 1960s. Highway 55 intruded itself between the riverfront area and the rest of downtown St. Louis. Highway 40/64 was built as a major thoroughfare that cut the city in two, dividing north and south, roughly along the lines between the predominantly African American neighborhoods and the predominantly white neighborhoods. With the lessening popularity of passenger rail travel, the St. Louis rail hub no longer accounted for an influx of tourists traveling through. The city would be forced to repackage its entire downtown area.

The 1970s was a decade of decline and rebuilding in St. Louis. The population declined from 622,236 in 1970 to 453,085 in 1980 because of the popularity of the new suburbs. Three mayors—Alfonso Cervantes, John Poelker, and James Conway—governed during the decade. They presided over the closure of Homer Phillips Hospital and City Hospital. Pruitt-Igoe, the public housing project designed by Minoru Yamasaki who also designed the World Trade Center, was imploded in 1972. The nightlife and popular music scene at Gaslight Square that was hugely popular in the 1960s faded away. The region looked and interacted differently after both Highway 40/64 and Highway 70, then referred to as the Mark Twain Expressway, were opened to traffic from east to west across the Mississippi River. The Ralston Purina Tower was completed in 1970, the Mercantile Tower was finished in 1975, and streetlights were installed in the downtown alleys in 1977. Other skyscrapers were built too: Laclede Gas Building, Equitable Building, Boatman's Tower, and Marriott Pavilion Hotel. In 1977, the Cervantes Convention Center opened near Laclede's Landing. Rehabilitating old buildings in historic neighborhoods like Soulard began to transform some of the rundown and abandoned areas of the city.

The 1970s was a decade of transition for the railroads in the St. Louis Gateway. Union Station closed to rail traffic in 1978 because the mammoth station served only six trains per day. This was down from a volume of 200 trains per day in the 1920s. In its place, a new Amtrak Station

was built devoid of any of the romance and ambition of its predecessor. Utilitarian and difficult to find, this small, supposedly temporary depot does not welcome a passenger to a thriving city or offer a taste of its haute culture. Almost as if in compensation, a new symbolic gateway to St. Louis, the Gateway Arch, dedicated in 1968 after nearly 30 years of bickering among the builders and decision makers, dominated the Mississippi riverfront. During the 1970s, the elevated levee tracks were torn down. The tracks in the street were removed. Trains were routed behind the Gateway Arch and underground through a tunnel that had been made exempt from the industry's standard height regulations for tunnels. The Eads Bridge closed to rail traffic in 1974, making the Eads Tunnel connections to the Cupples Station complex of freight sheds and this TRRA connection between Eastern and Western Railroads useless, until the Metrolink Light Rail System would redevelop the bridge in the 1990s.

It was not just the St. Louis Gateway that had to adjust to major changes in the 1970s. According to the United States Department of Transportation in *Western Railroad Mergers: A Staff Study by the Office of the Assistant Secretary for Policy Development*, January 1969, between 1957 and 1970, the nation's railroads had experienced "the most significant reorganization of any American industry since the turn of the century." By 1980, the railroads accounted for 37.5 percent of the nation's freight market share, down from 74.9 percent in 1929, 44.1 percent in 1960, and 39.8 percent in 1970. Major railroads consolidated, merged, and went bankrupt in the 1960s and 1970s. This made the 1970s a railfan photographer's delight—not only were old cars and engines running, new paint schemes and heralds showed up every day.

One
Terminal Railroad Association and Manufacturer's Railway Company

Both the Terminal Railroad Association of St. Louis (TRRA) and the Manufacturer's Railway Company operate solely inside the St. Louis Gateway. TRRA was formed by an association of major railroads in the last decade of the 19th century to break the stranglehold that the Wiggins family's ferry service held over the Mississippi River traffic into St. Louis. So the TRRA financed the construction of the Merchant's Bridge in North St. Louis. It also built the St. Louis Union Station on Market Street, which was completed in 1894. TRRA owned yards there and in Madison, Illinois, all the tracks on the west side of the river from Merchant's Bridge to Union Station, and the Eads Tunnel that connected Eads Bridge to the Cupples Station complex of freight sheds. In other words, TRRA is to railroad what Wiggins was to river—the St. Louis gatekeeper, controlling the entry and egress of all the trains. TRRA member railroads shared dividends on the fees collected from the railroads for the right to use its bridge and tracks.

The Manufacturer's Railway belongs to the Anheuser-Busch Brewery. As early as 1877, the brewery utilized 40 refrigerator cars, and in 1887, the brewery began to operate its own railroad. In addition to servicing the brewery, the more than 42 miles of Manufacturer's Railway track runs along the Mississippi River in South St. Louis city, servicing and providing switching for other downtown industries. At the brewery, the tracks turn north. Another line connects to the Missouri Pacific Railroad at Arsenal Street. The railroad uses the Riverfront Yard and another yard south of Dorcas Street.

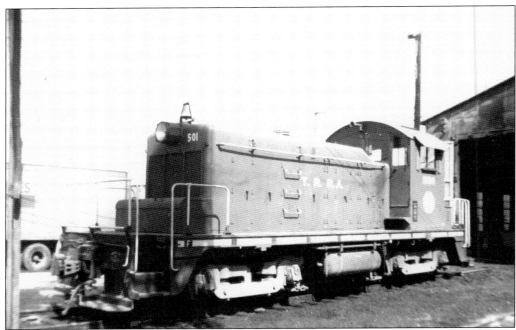

TRRA SW-1 LOCOMOTIVE NO. 501. This SW-1 locomotive was built in 1940, with 600 horsepower. It cost the railroad $60,900 to buy. In May 1972, it was sold to and eventually scrapped by the Columbus and Greenville Railroad. When Union Station closed in 1978, the TRRA's fleet of SW-1 switcher locomotives became redundant because they were devoted to pulling the mail cars on incoming trains.

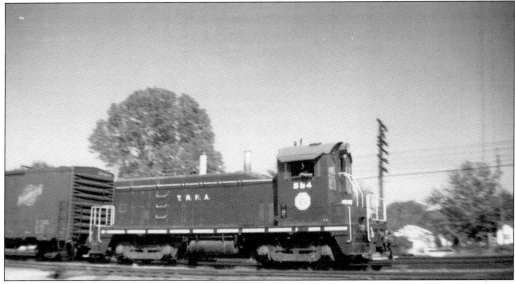

TRRA NW-2 LOCOMOTIVE NO. 554. This NW-2 locomotive was built by the Electro Motive Division (EMD) of General Motors in 1941, with 1,000 horsepower. It cost $78,920 and was sold to Precision National in 1977. It is shown in Dupo, Illinois, on May 17, 1970. The TRRA tracks led from the Missouri Pacific Dupo yards at Illinois Highway 3 and State Street to East St. Louis and across the river via the MacArthur Bridge.

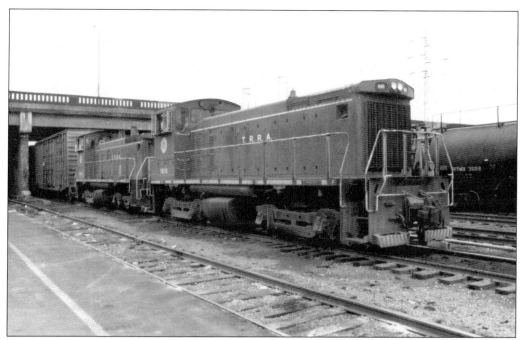

TRRA SW-1500 LOCOMOTIVES NO. 1515 AND 1503. These switchers are shown at the new Amtrak Station of St. Louis, Missouri, on April 8, 1979. No. 1503 was built in 1967, and No. 1515 was built in 1972. SW-1500s have a horsepower of 1,500.

TRRA SW-1200 LOCOMOTIVES AND CABOOSE. These cars are waiting at the levee tracks of East St. Louis, Illinois, on October 7, 1979. TRRA conducted switching services for railroads whose trains were moving west across the Mississippi River through St. Louis. TRRA maintained switcher locomotives and cabooses only.

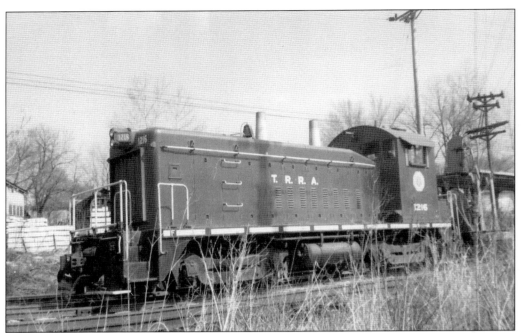

TRRA SW-9 LOCOMOTIVE NO. 1216. This locomotive was built in 1952, with 1,200 horsepower. TRRA used these locomotives to service local industries like the Granite City Steel Company in Illinois and the Chevrolet plant in St. Louis city. In 1987, the locomotive was sold to the Lange Stegman Fertilizer Company.

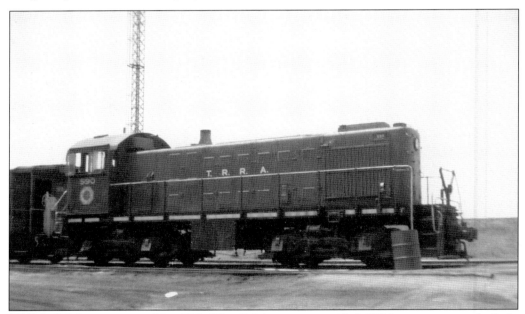

TRRA S-2 LOCOMOTIVE NO. 590. This S-2 locomotive with 1,000 horsepower was built in 1949 by the American Locomotive Company (ALCO). TRRA paid $98,900 for it and sold it, in 1975, to George Silcott of Columbus, Ohio. It is shown by the dyke at East St. Louis, Illinois, on May 30, 1974.

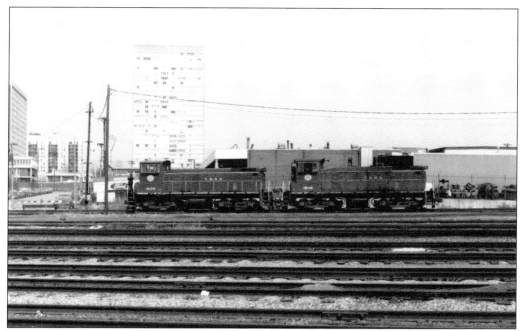

TRRA SW-1500s. Switcher locomotives SW-1500 No. 1505 and No. 1506 are parked together in the Mill Creek yards of downtown St. Louis at Theresa Avenue. TRRA's operations in St. Louis were forced to make adjustments in the 1970s because of the transformation of the gateway itself and because of changes in the railroad industry.

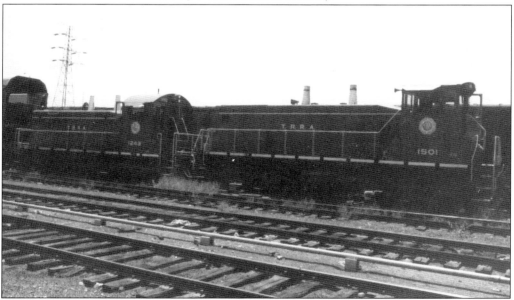

TRRA LOCOMOTIVES AT THE NEW AMTRAK STATION. SW-1500 locomotive No. 1501 was built in 1967, and SW-1200 locomotive No. 1243 was built in 1965. They are shown at the new Amtrak Station of St. Louis, Missouri, on August 4, 1979. When Eads Bridge closed to rail traffic in 1974 and the high line was removed from the riverfront in front of the Gateway Arch, TRRA's Eads District downsized its operations.

15

TRRA WITH DOWNTOWN ST. LOUIS BUILDINGS. The 1923 building with the pyramid on top is the Civil Courts Building. TRRA serviced the Granite City Steel Company in Granite City, Illinois, and, among others on the Missouri side of the river, the Chevrolet plant and the Fisher Body Division Plant. At the beginning of the decade, TRRA delivered around 2,500 carloads of car parts into the area and around 255 newly built automobiles on tri-level automobile racks each month. The TRRA Bremen Avenue Yard closed in 1976, and the Bremen Avenue Diesel Pit closed in 1977. This was partially due to railroads' increasing reliance on the Alton and Southern (A&S) Gateway Yard for switching services into St. Louis.

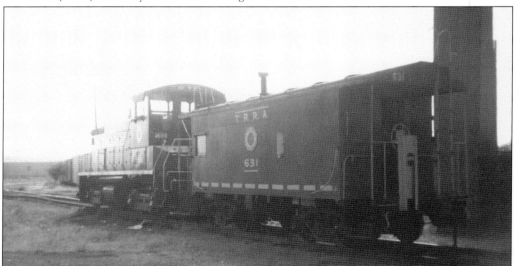

TRRA IN NATIONAL CITY, ILLINOIS. Caboose No. 631 lacks both a cupola and a bay window. The SW-1500 locomotive No. 1506 is an EMD of General Motors locomotive with 1,500 horsepower built in November 1969. They are standing at National City, Illinois, on May 30, 1970. National City is on Illinois Highway 3 just east of Brooklyn, Illinois, where the National Stockyards were.

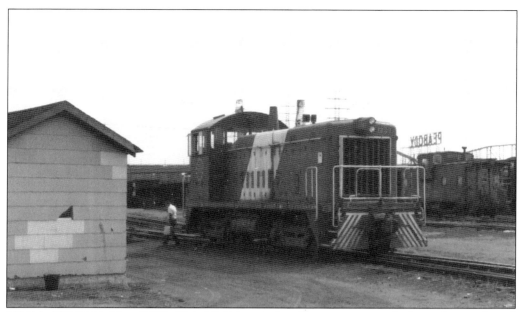

TRRA SW-1200 No. 1207. This TRRA switcher locomotive is parked on the south end of the levee tracks in East St. Louis, Illinois, behind the Peabody Coal Company on May 30, 1977. The cab is black and the hood is painted red with a wide diagonal white stripe, a notable departure from the usual solid red paint scheme. Some Burlington Northern (BN) cars are in the background.

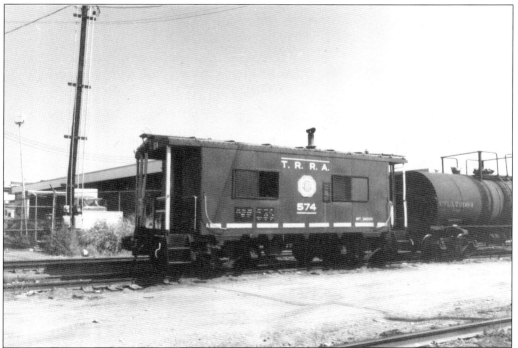

TRRA Caboose No. 574. This caboose is on the Norfolk and Western (NW) track at Theresa Avenue in midtown St. Louis, Missouri, on September 25, 1979.

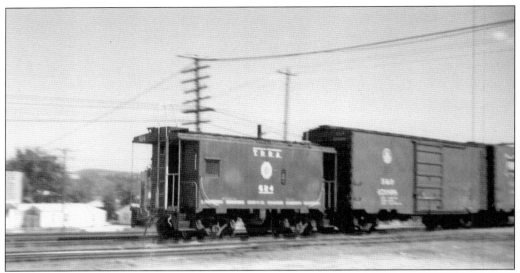

TRRA Caboose No. 624. The TRRA caboose trails a Baltimore and Ohio (B&O) boxcar in Dupo, Illinois, on May 17, 1970. Dupo is where the Missouri Pacific (MP or MOPAC) yards were located on Illinois Highway 3.

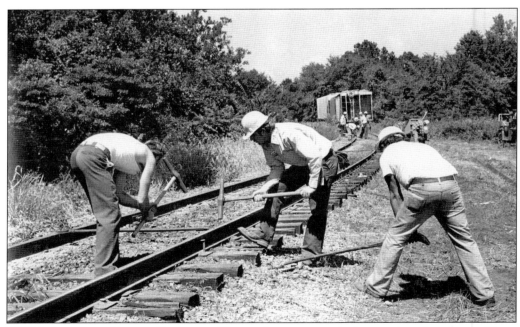

TRRA Crew of Gandy Dancers. The workmen are replacing rotting ties after a 10-car derailment. The derailed train included tank cars filled with liquid propane. The accident was reported in the newspaper on September 1, 1978. (Courtesy of the St. Louis-Globe Democrat archives of the St. Louis Mercantile Library, University of Missouri-St. Louis.)

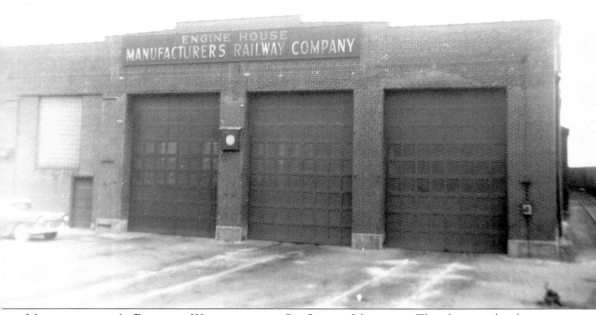

MANUFACTURER'S RAILWAY WAREHOUSE IN ST. LOUIS, MISSOURI. The shop at the foot of Arsenal Street at First Street near the Anheuser-Busch Brewery rebuilt a lot of cars for the Manufacturer's Railway Company, turning 40-foot ice refrigerators into 50-foot diesel refrigerators. They used the side panels from the old cars and put more insulation in them so that they could go from coast to coast and stay cold. At one time, the brewery operated over 1,000 of these insulated reefers. TRRA contracted with Manufacturer's Railway shops for painting and maintenance after its own Brooklyn, Illinois, shops burned.

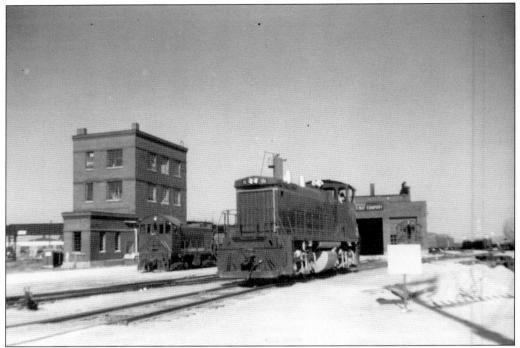

Manufacturer's Railway MP15DC Locomotive No. 251. The EMD built this locomotive, which stands near the Manufacturer's Railway engine house at the foot of Arsenal Street in St. Louis on June 12, 1974. Behind it stands an ALCO S-2 locomotive.

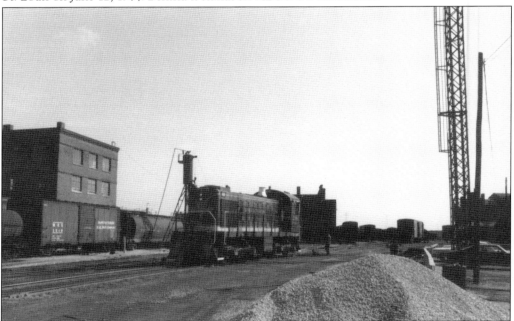

Manufacturer's Railway ALCO S-2 Switcher No. 206. This locomotive stands in front of the arsenal in St. Louis on April 8, 1979. A pile of gravel is in the foreground in front of a crane, and several other cars are parked on the track behind the S-2 locomotive.

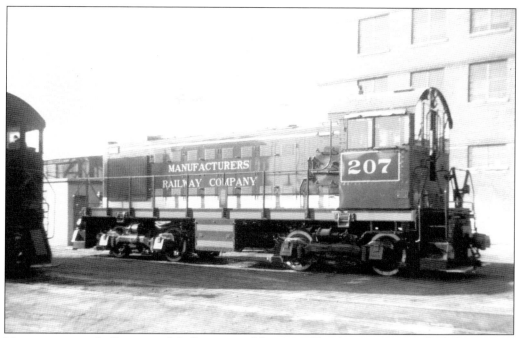

MANUFACTURER'S RAILWAY S-2 SWITCHER NO. 207. This locomotive was built by ALCO. Manufacturer's Railway used S-2 switchers to transfer freight to the A&S Gateway Yard in East St. Louis, Illinois, via the MacArthur Bridge, which is just south of the Gateway Arch.

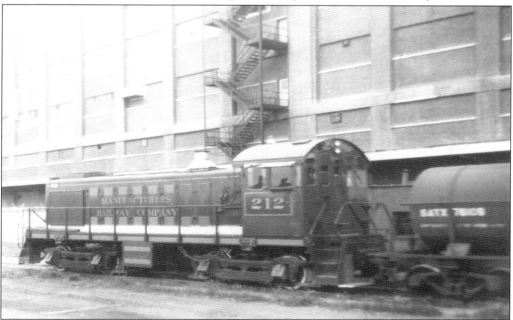

MANUFACTURER'S RAILWAY SWITCHER NO. 212. This is an ALCO S-2 locomotive with American Association of Railroads (AAR) trucks. Manufacturer's Railway always used a solid green paint scheme in keeping with the exterior of the brewery. All the windows are trimmed in this same green color.

21

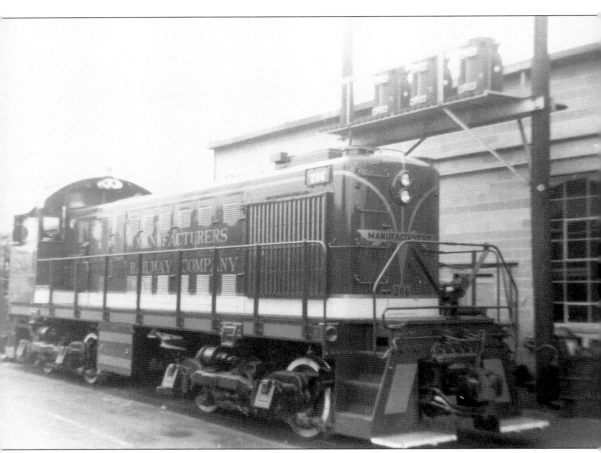

Manufacturer's Railway ALCO S-2 Locomotive No. 206. This locomotive is painted green with yellow lettering and a white stripe at the base of the body. Red stripes adorn the floor line. The locomotive sits at the foot of Arsenal Street near the Manufacturer's Railway shops.

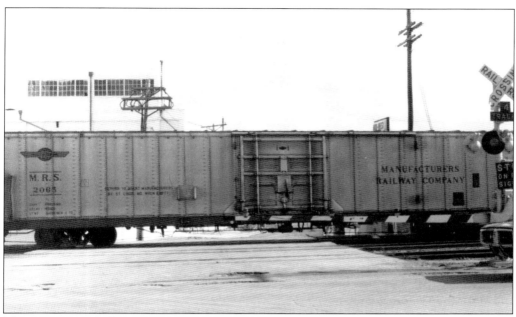

MANUFACTURER'S RAILWAY 50-FOOT BOXCARS. Boxcar No. 2065 is shown above. Below, at the Kingshighway Viaduct in July 1977, is Boxcar No. 4983. The St. Louis Refrigerator Car Company, owned by Anheuser-Busch, builds these for Manufacturer's Railway. Beginning with the side walls from old 40-foot Manufacturer's Railway cars, one and one half feet of height and five feet of length is added to form new 50-foot insulated boxcars that can keep a load cool from coast to coast. Other Manufacturer's Railway reefers have a diesel refrigerator unit built in to continue to cool the load. The refrigerator cars tend to have plug doors to insure a tight seal. Some of the refrigerator cars use extended pocket couplers to protect the cargo from jolts and bumps. The boxcars are grey on the top and black on the bottom with a red stripe.

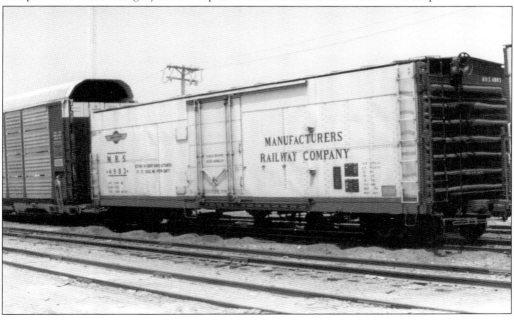

23

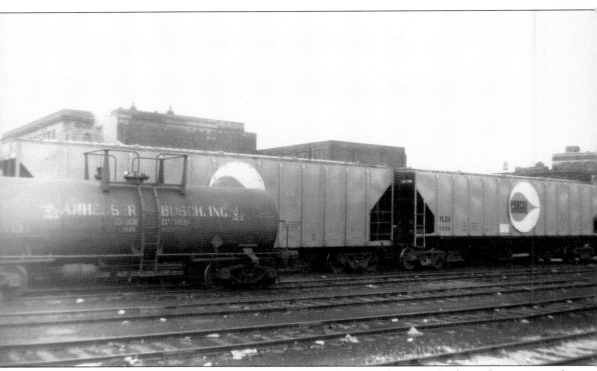

ANHEUSER-BUSCH TANK CAR. Besides owning the Manufacturer's Railway that services the industries in downtown St. Louis, Anheuser-Busch brands tank cars like this one shown in front of two covered hoppers owned by Cargill. It is as much to gain advertising as to identify the owners of railroad cars that companies chose to mark them with their familiar names and trademarks. This tank car carries the company name, Anheuser-Busch Incorporated, as well as the flying eagle in the middle of the capital A. The car is marked "corn syrup."

Two

Major Railroads in the St. Louis Gateway

Locomotives and rolling stock from 29 railroads comprise the following images. Some of the railroads were already considered fallen flags during the 1970s like the Penn Central (PC). Other flags, most notably for the St. Louis region MP and St. Louis-San Francisco (Frisco), would fall before the end of the decade. A few, like BN and NW, grew into mega-railroads as a result of mergers. The images are presented in alphabetical order by railroad, regardless of whether or not it was a fallen flag at the time of the photograph. Within railroads, locomotive images are first, followed by cabooses, boxcars, refrigerator cars, open hoppers, covered hoppers, gondolas, flatcars, and tank cars. The captions identify where and when the car was photographed. The captions also present information about the railroad and the location in the St. Louis Gateway where the car was photographed.

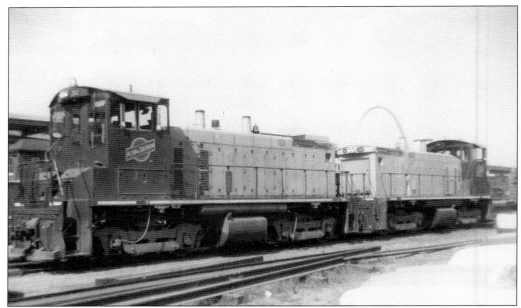

A&S SW-1500 LOCOMOTIVES. A&S SW-1500s No. 1511 ahead and No. 1503 behind enter the St. Louis yards from MacArthur Bridge in August 1971. The Gateway Arch is visible in the hazy background. To manage the steep grade of the entrance to the MacArthur Bridge to transfer A&S cars at the Gateway Yard of East St. Louis, Illinois, required several locomotives.

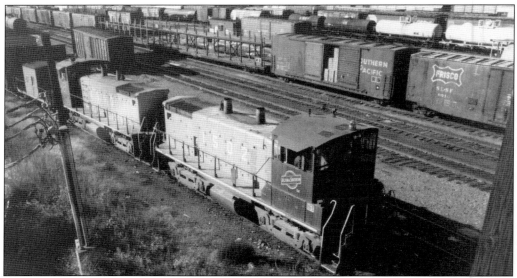

A&S SW-1500 LOCOMOTIVES. A&S SW-1500 locomotives No. 1502 and No. 1513 are parked on the MP tracks in the Mill Creek Valley. MP and Chicago North Western (CNW) combined to buy the A&S in 1968. The majority of the railroad's locomotive power was made up of SW-1500 switchers with yellow hoods and blue cabs. The herald is a collage that echoes the MP's buzz saw behind the diagonal herald similar to that of CNW. This photograph was taken from the Eighteenth Street Viaduct on October 15, 1978.

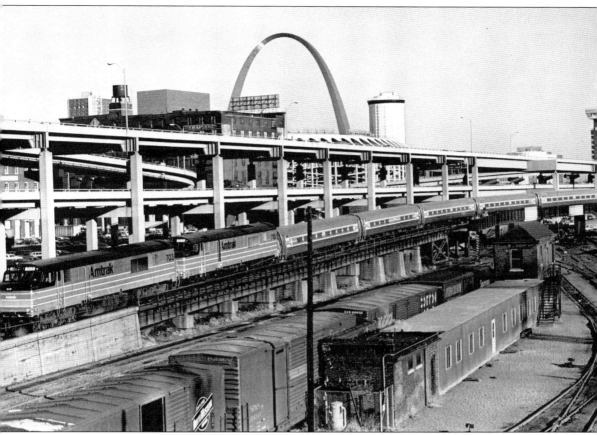

AMTRAK ENTERS THE ST. LOUIS GATEWAY. The Gateway Arch, opened in 1968, and Busch Stadium, opened in 1966, are both visible behind Highway 40/64. The Amtrak train is heading west from the MacArthur Bridge and the temporary Amtrak Station on its way to Kirkwood, Jefferson City, and Kansas City. (Courtesy of the St. Louis-Globe Democrat archives of the St. Louis Mercantile Library, University of Missouri-St. Louis.)

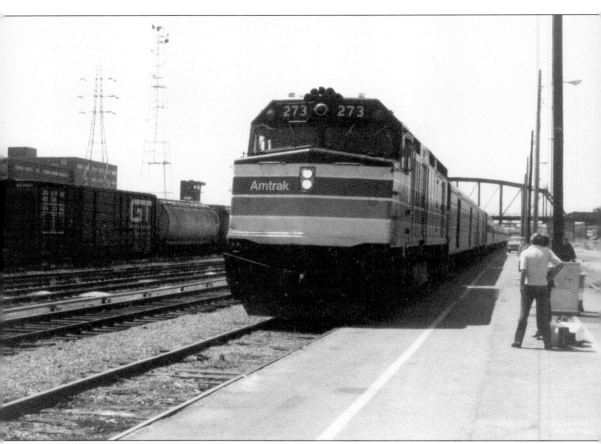

AMTRAK F-40 LOCOMOTIVE NO. 273. Amtrak began operating on May 1, 1971, according to the federal Rail Passenger Service Act passed by congress in October 1970 and signed into law by Pres. Richard Nixon. Following the failure of the attempt to consolidate the northeastern railroads in a fiscally efficient company, which was supposed to have been the Penn Central, the management of that troubled railroad appealed to the federal government for assistance. The result was the formation of two government supervised railroads: Conrail, to deal with the freight traffic, and Amtrak, to deal with the passenger traffic.

AMTRAK F-40 LOCOMOTIVE NO. 314. Amtrak EMD F-40 No. 314 is parked at the new Amtrak Station of St. Louis on August 4, 1979. This locomotive was subsequently sold to Rail World Locomotive Leasing. Whereas Amtrak did not have a network of its own tracks, the individual railroads did not have sufficient demand for passenger travel to warrant scheduling and running passenger trains. In fact, the passenger business was a drain on the business of all of the American railroads. Amtrak, a government operation, is controlled by the secretary of transportation.

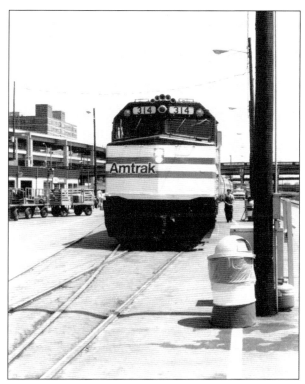

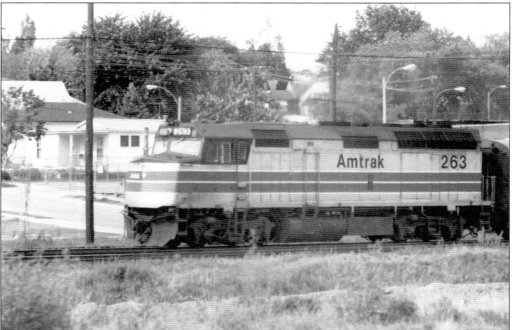

AMTRAK EMD F-40 LOCOMOTIVE NO. 263. This locomotive runs along Manchester Road at Knox Avenue just east of the Scullin Steel Company on May 9, 1979. It was later removed from the Amtrak roster and sold to Rail World Locomotive Leasing.

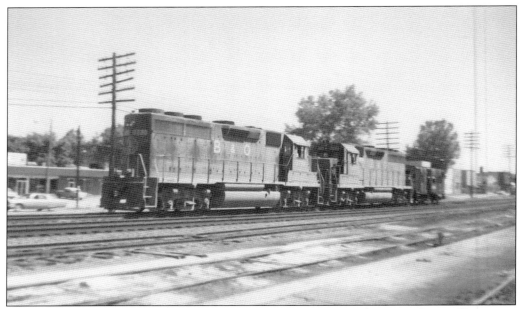

B&O GP-40 Locomotive No. 3730. These locomotives are shown in Dupo, Illinois, on May 17, 1970. The inscribed hollow capital herald is just visible on the rear. B&O and the Chesapeake and Ohio (C&O) merged beginning in 1966 and, together, joined the Chessie System in 1973. In 1978, the Chessie System merged with the Family Lines to form CSX. Louisville and Nashville (LN), which had already bought the Nashville Chattanooga and St. Louis, joined the CSX merger to give B&O access to St. Louis.

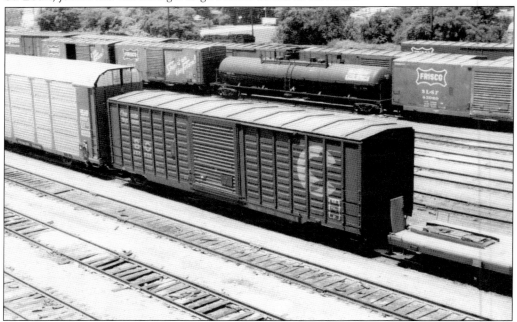

B&O Boxcar No. 486538. This 50-foot waffle-side boxcar of the Chessie System carries the "sleep like a kitten" herald. It is parked in the Frisco Lindenwood yards and photographed in June 1978 from the Arsenal Street Viaduct.

30

B&O Covered Hopper No. 830055. This yellow air-slide covered hopper with blue lettering and the sleep like a kitten herald is coupled next to a grey Texas and Pacific air-slide covered hopper No. 720234. The Texas and Pacific car carries the MP buzz saw herald because the railroad is a subsidiary of MP. Both are parked in the Mill Creek yards of St. Louis on April 16, 1979.

B&O Covered Gondola No. 35910. A yellow B&O Chessie System Alcan covered hopper No. 625024 with the sleep like a kitten herald is in front of a black covered gondola No. 35910. The gondola is painted yellow and also bears the sleep like a kitten herald. On March 13, 1979, the cars were passing underneath Kingshighway on the Frisco track in St. Louis, Missouri.

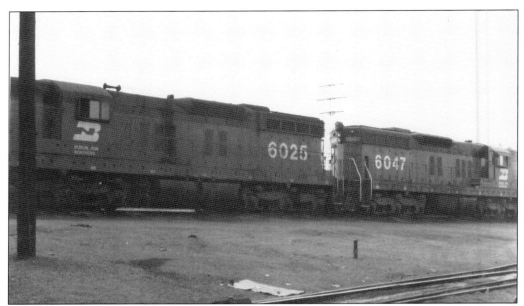

BN SD-9 Locomotives No. 6025 and No. 6047. These locomotives are shown on the north levee tracks of East St. Louis, Illinois, on May 30, 1977, seven years after the BN's formation by the merger of four major railroads, Chicago, Burlington and Quincy (CBQ), Great Northern (GN), Northern Pacific, and Spokane, Portland and Seattle, on March 2, 1970. SD-9 locomotives have 1,750 horsepower and were built in the late 1950s.

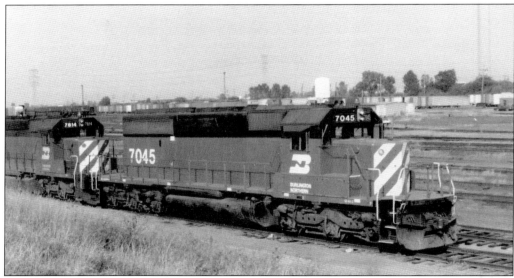

BN SD-40-2 Locomotives No. 7045 and No. 7814. These locomotives are behind the levee in East St. Louis, Illinois, on October 7, 1979. No. 7045 was built in February 1978. No. 7814 was built in June 1977 and originally carried Colorado and Southern reporting marks No. 944. According to author Robert C. Del Grosso, BN chose to make "cascade green" its official color because none of the merger participants nor any other BN competitor used green, so this choice allowed for an immediate visual association with the new railroad.

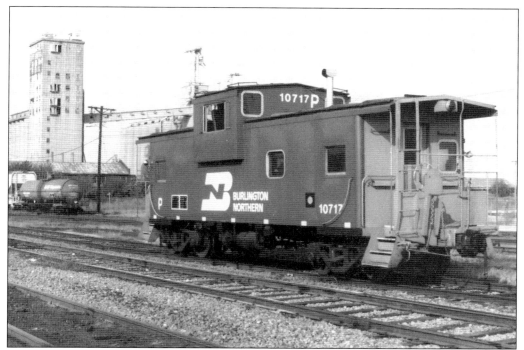

BN Caboose No. 10717. This wide-vision caboose sits on the Illinois Central Gulf (ICG) tracks near the levee of East St. Louis, Illinois, on October 7, 1979. The ends are painted yellow, and the sides and cupola are painted cascade green with white lettering.

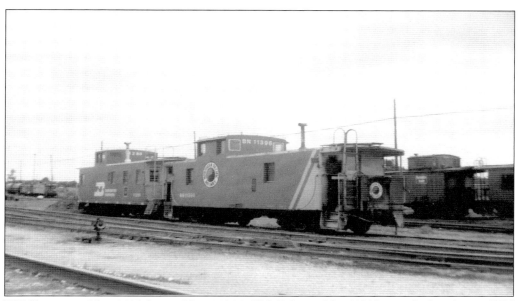

BN Cabooses No. 11396 and No. 11280. BN Caboose No. 11280 is parked in front of BN Caboose No. 11396 in the CBQ yards of East St. Louis, Illinois, on May 30, 1974. No. 11396 still carries the Northern Pacific herald of its former owner, one of the four railroads that merged to form the BN.

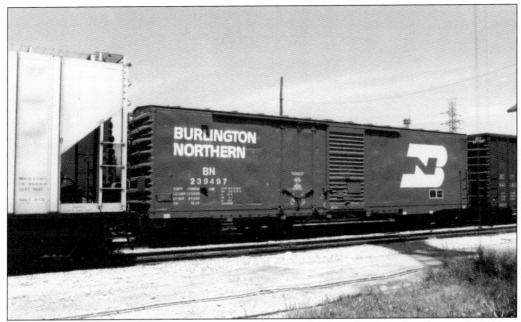

BN Boxcar No. 239497. This 50-foot boxcar has two different doors, a plug door and a sliding door. The inside length is 49 feet. The AAR, organized in 1934, oversees the types of cargo that are permissible to be carried in this kind of boxcar.

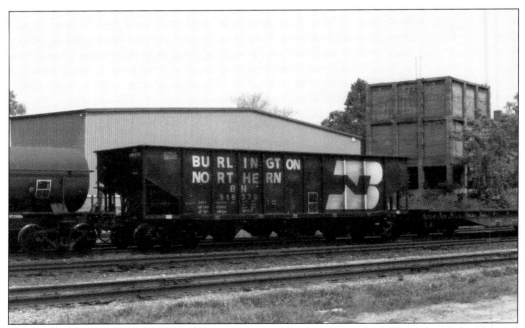

BN Open Hopper No. 516379. This empty open hopper is on the MP tracks of the Central Industrial Drive behind Vandeventer Avenue in August 1978. This type of hopper is often used to carry coal, gravel, or ballast loads. From here the train would switch to the Frisco tracks to go west to the Lindenwood yards. By the end of the decade, in 1980, BN would acquire the Frisco.

34

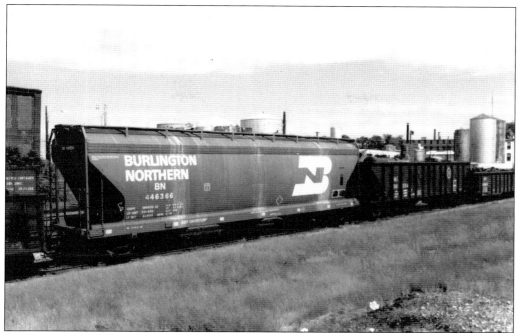

BN COVERED HOPPERS. The three-bay covered hopper, above, No. 446366, was built by American Car and Foundry (ACF) Industries, which is headquartered in St. Charles. St. Charles is directly to the west of St. Louis County across the Missouri River. Below, No. 448255 was built by the Pullman Standard Car Manufacturing Company. Both covered hoppers were in the Central Industrial Court of St. Louis in September 1978. Covered hoppers usually have a capacity of 100 tons or between 4,000 and 5,000 cubic feet. They use gravity for unloading and have a permanent roof. The first covered hoppers were used for concrete, which needed to be transported absolutely dry.

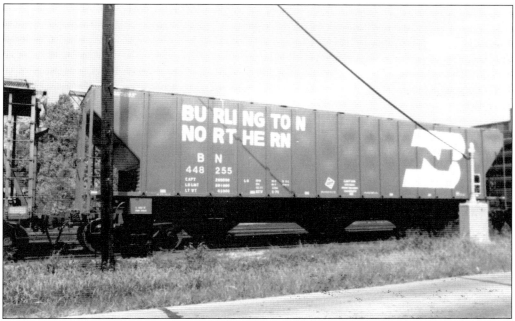

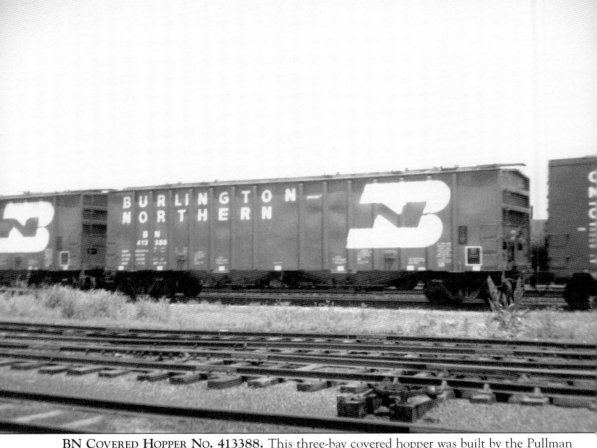

BN Covered Hopper No. 413388. This three-bay covered hopper was built by the Pullman Standard Car Manufacturing Company. The company grew from the one founded by George Pullman, famous for Pullman Town, passenger cars, and porters. Pullman purchased Standard Steel in 1930 at the beginning of the end of the passenger railroad era. Eventually the monopoly was broken up by order of the federal government of the United States.

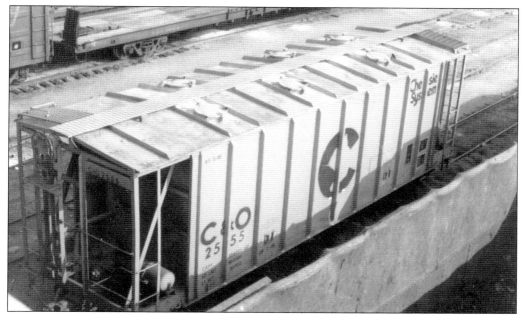

C&O Covered Hopper No. 2555. The C&O merged with the B&O to form the Chessie System in 1972. This was to answer the increasing competition from the NW and gave C&O access to St. Louis. This C&O covered hopper was photographed on July 14, 1978, in the Frisco Lindenwood yard at the Arsenal Street Viaduct.

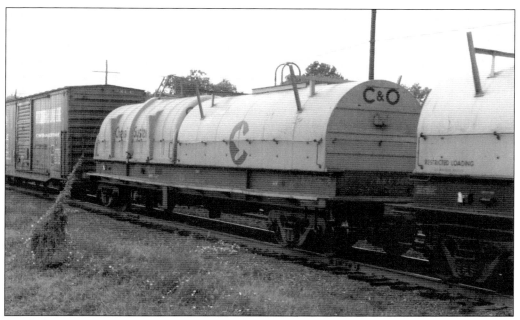

C&O Steel Coil Car No. 306387. Steel coil cars are special covered gondolas. This one displays the sleeps like a kitten herald. The kitten mascot first appeared in an advertising campaign in 1934. The icon stuck. This car is on the MP tracks on Manchester Road in St. Louis in August 1978.

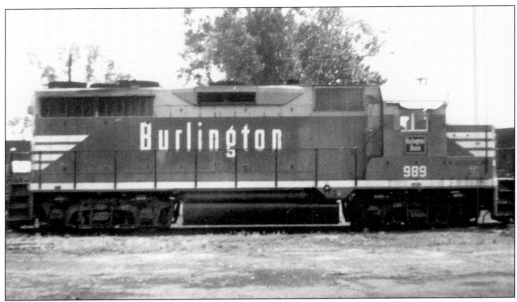

CBQ GP-35 LOCOMOTIVE NO. 989. Like the B&O, the CBQ, called the "Burlington Route," was responsible for a lot of railroad firsts. It was the first railroad to provide direct service between Denver, Colorado, and Chicago, Illinois. It was the first railroad to use a print telegraph and the first to use radio communications. Its 1934 *Pioneer Zephyr* was the first passenger train to use a diesel locomotive, and in 1945, it produced the first vista-dome passenger car.

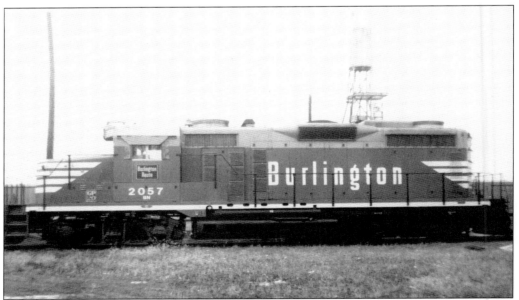

CBQ GP-20 LOCOMOTIVE NO. 2057. The railroad used two slogans: "Everywhere West" and "Way of the Zephyrs," which refers to a series of streamlined passenger trains named after the gentle west wind to connote, for the passengers, the promise of a quiet and gentle ride. Often one slogan is on the port side of a car while the other is on the starboard side. Burlington Route locomotives were painted bright Chinese red with grey, white, and black details and white stripes.

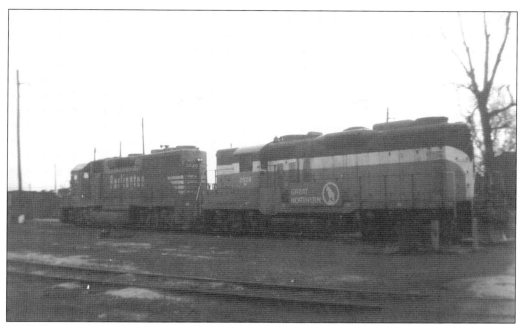

CBQ Locomotive No. 3020. This Burlington locomotive is coupled to GN locomotive No. 2028. Both railroads were participants in the 1970 BN merger so it was not unusual to see them double-headed. The GN inscribed mountain goat herald was rarely seen in the St. Louis Gateway, however.

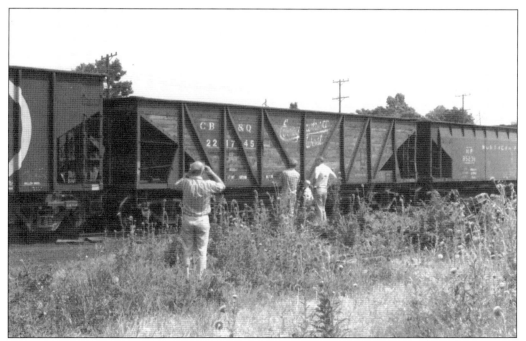

CBQ Open Hopper No. 221745. This wood outside-braced open hopper carries the old Burlington Route slogan "Everywhere West." Used to carry ballast, it was 40 feet and 9 inches long.

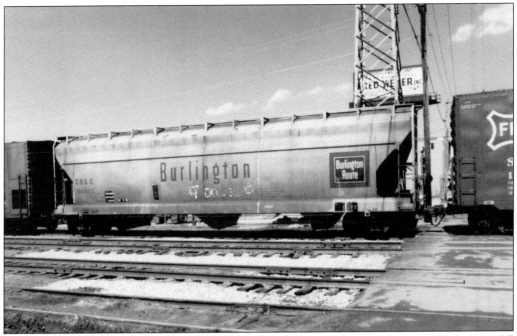

CBQ Covered Hopper No. 184453. This three-bay covered hopper was built by ACF Industries. It is 55 feet and 6 inches long. It could have delivered granulated sugar to the Great Western Sugar Terminal of St. Louis or grain to the Burlington Elevator Company.

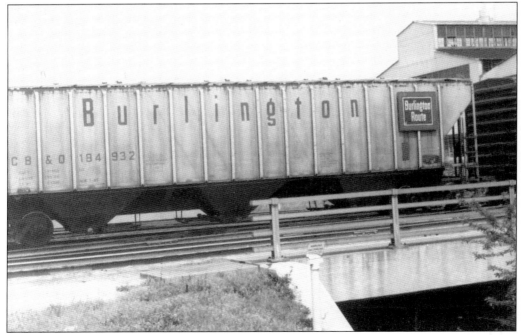

CBQ Covered Hopper No. 184932. This 54-foot-long covered hopper was built by the Pullman Standard Company. This type of hopper was used to ship out fertilizer from the Lange Brothers Company of St. Louis.

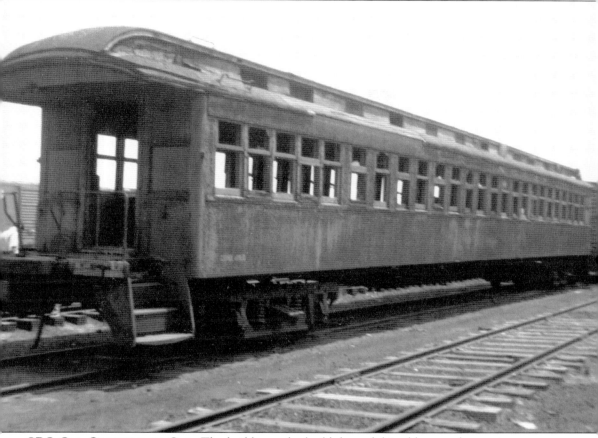

CBQ OLD OBSERVATION CAR. The builder or the build date of this old rusty observation car are not known. Most of the Burlington passenger cars did not receive numbers. Rather, they were named. Some of the names that the railroad gave to observation cars are *Juno*, *Jupiter*, *Flash*, *Streak*, *Spirit*, and *Star*. The CBQ yard was in North St. Louis city on Hall Street between Prairie and Humbolt Streets. After 1970, this yard was used for very few trains that handled local service or coal. By 1980, the railroad, having acquired the Frisco, operated mostly out of the Lindenwood yards along the River Des Peres in West St. Louis city.

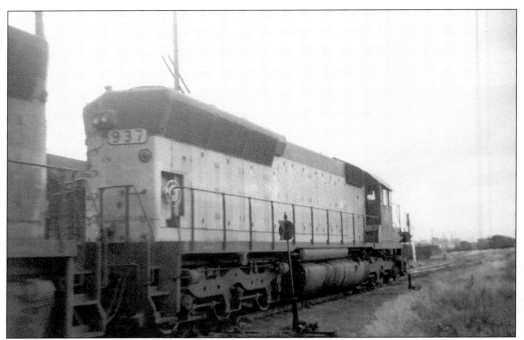

CNW SD-45 Locomotive No. 937. The CNW's first locomotive, *Pioneer*, is the inspiration to its nickname, "the Pioneer Railroad." The railroad, which began operating out of Chicago in 1848, served the coal fields in southern Illinois as well as its own Superior Coal Company Mines. In the 1950s and 1960s, the railroad expanded by buying smaller midwestern railroads. In 1972, the employees bought the railroad and kept it running, à la Southwest Airlines, for 10 years. Above is a close-up view of SD-45 locomotive No. 937. Below, the same locomotive is shown with others at National City, Illinois, on May 30, 1970.

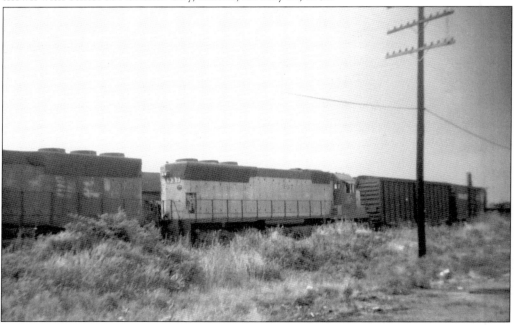

CNW SD-45 No. 937. This view of the same locomotive, which does not have a dynamic brake, was taken at the A&S yard of East St. Louis, Illinois, on October 7, 1979. The CNW Railroad always came to East St. Louis where it had a freight shed and a shipping yard. Through the purchase of the Litchfield and Madison Railroad in 1958, it gained entry to St. Louis where it increased its presence, in 1960, under Ben Heineman's management, after it purchased the Minneapolis and St. Louis Railroad. After the employees bought the CNW Railroad in 1972, they were proud enough of the achievement to incorporate the words "employee-owned railroad" into the "ball and bar" trademark herald. When the employee-owned structure was abandoned in 1982, the trademark reverted to the older wording.

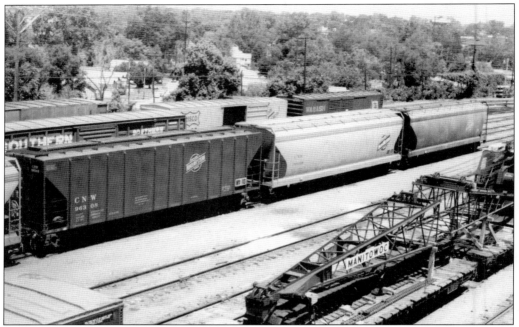

CNW Covered Hoppers. A Pullman Standard PS-2 covered hopper No. 96308 and an ACF center-flow covered hopper No. 180398 are coupled next to each other in the Frisco Lindenwood yards. The view is from the Arsenal Street Viaduct in St. Louis in June 1978.

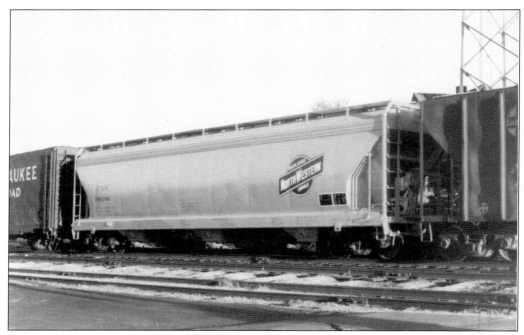

CNW Covered Hopper No. 180206. This ACF covered hopper is shown with the new "employee-owned railroad" trademark herald and new yellow paint on the Frisco tracks at Knox Avenue in St. Louis. The car is heading west, bound for the Lindenwood yards in October 1977.

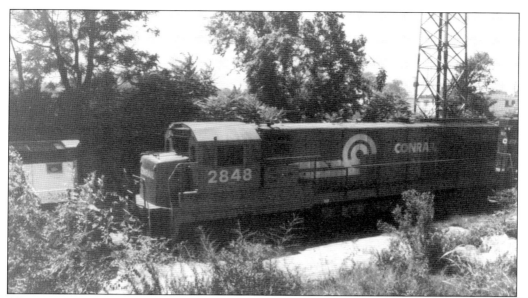

CR U-28-C LOCOMOTIVE NO. 2848. After the failure of the Penn Central, formed in 1968, to solve the problems that had plagued its merger partners, New York Central (NYC) and Pennsylvania Railroads, an appeal to the federal government determined that the industrial northeastern United States needed a competent railroad system. This resulted in the formation of Conrail (CR) in 1976 to handle freight on the lines formerly operated by six railroads. According to Jerry A. Pinkepank, only around 71 U-28-C locomotives, built by General Electric in 1965 and 1966, were sold in the United States. This one was on the Frisco tracks near Tower Grove Avenue in St. Louis in July 1978.

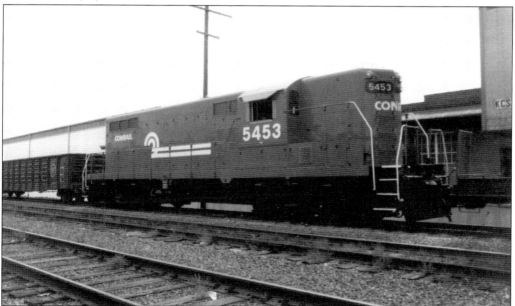

CR GP-9 LOCOMOTIVE NO.5453. Conrail specialized in hauling heavy industrial goods, grain, or coal in long unit trains over long distances. This GP-9 locomotive is beside Manchester Road near Macklind Avenue in St. Louis in September 1978.

45

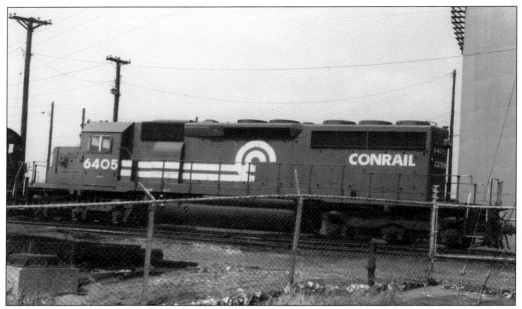

CR SD-40 Locomotive No. 6405. As a large, federally supported company, Conrail could operate efficiently and shut down parallel lines. This SD-40 locomotive, built by the EMD of General Motors between 1966 and 1970, has the telltale radiator roof fans at the rear of the long hood. This one is at the MP engine facilities on Ewing Avenue in St. Louis.

CR U-25-B Locomotive No. 2567. Conrail was so successful at managing freight railroad services that by 1981, only five years after being formed, Conrail made a profit. This high nose road switcher locomotive is behind another U-25-B near Manchester Road in St. Louis in August 1978. There were 478 U-25-B locomotives built by General Electric with 2,500 horsepower between 1959 and 1966.

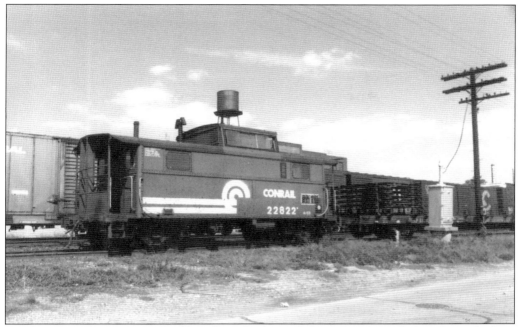

CR Caboose No. 22822. This blue all-steel caboose belonged to the N-5 class. It was built in 1941. The toolbox was one unit with the body, and a stream-lined cupola tops the car. It probably was acquired by Conrail from the Pennsylvania caboose roster. This caboose is shown at the Central Industrial Court in St. Louis in September 1978.

Brown Conrail Caboose. This Conrail caboose in the Frisco Lindenwood yard is very short. It is parked on a track in front of a pair of boxcars. The view is toward Manchester Road looking north from the Arsenal Street Viaduct in St. Louis in June 1978. At this point the yard is parallel to the River Des Peres and to McCausland Avenue.

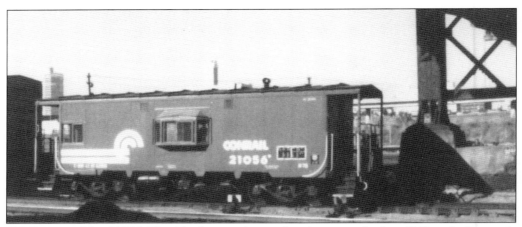

CR Caboose No. 21056. This blue bay window–style caboose was built in 1963 at the Despatch Shops. It is shown on the MP tracks from the Twenty-second Street Viaduct in St. Louis on October 15, 1978. Because of its legacy from the bankrupt railroads from which it was formed, Conrail obtained a diverse lot of equipment. The railroad also inherited some high-volume heavy-trafficked track and many miles of Podunk lines.

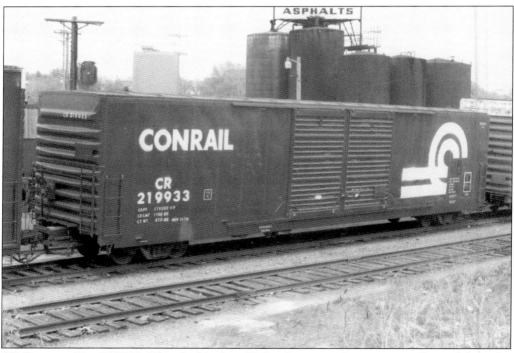

CR Boxcar No. 219933. This double door 50-foot boxcar perhaps came to Conrail from the Pennsylvania roster. It is shown on the Frisco tracks near Knox Avenue and the River Des Peres in St. Louis in April 1977. Conrail also obtained stations, warehouses, trackage, supplies, yards, and a huge amount of personnel along with the debt and assets of the defunct railroads from which it was formed.

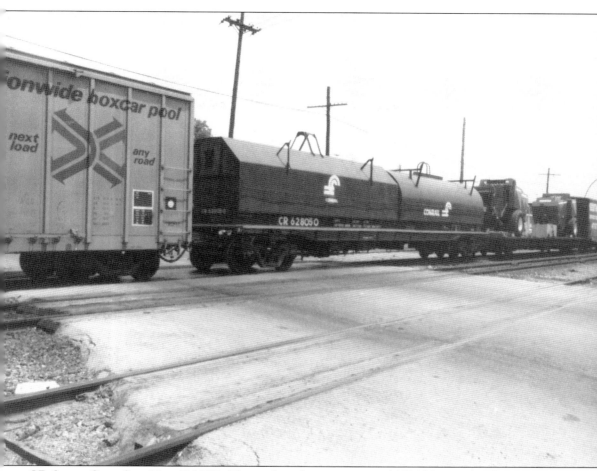

CR STEEL COIL CAR NO. 628050. This coil car has a capacity of 187,000 pounds. There are two covers, one curved and one angular, to keep the steel protected and dry. It is coupled next to a yellow boxcar that belongs to the Nationwide Boxcar Pool that pledges to customers "next load—any road." The train is on Manchester Avenue in St. Louis on June 6, 1979.

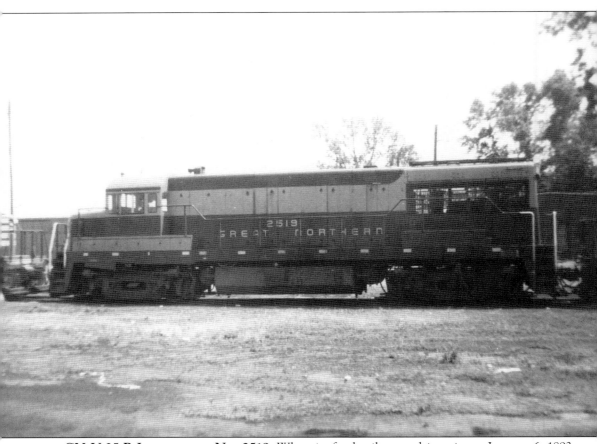

GN U-25-B Locomotive No. 2519. When its final spike was driven in on January 6, 1893, the GN, the "Route of the Empire Builders," became the second railroad to connect the Pacific Ocean with the Midwest. On March 2, 1970, GN participated in the four-way merger to form the BN. Before this time, although GN never operated in St. Louis, its rolling stock could be seen in St. Louis on MP trains coming east from San Francisco, California. After the merger, the "great sky blue" boxcars with the white inscribed mountain goat herald could sometimes be seen at the St. Louis BN yards waiting to be repainted. This U-25-B locomotive is shown at the CBQ engine facilities on Hall Street in St. Louis on May 30, 1970.

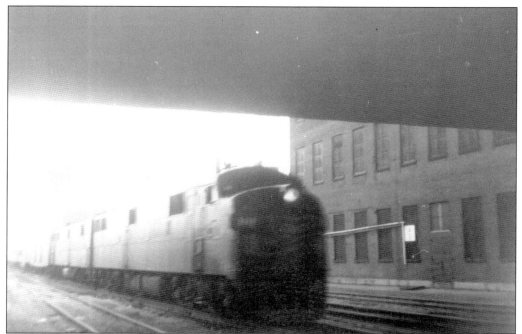

GMO LOCOMOTIVES. An EMD passenger locomotive in the E series is shown under the Merchant's Bridge in north St. Louis on April 19, 1970, above. Below, Gulf, Mobile and Ohio (GMO) SD-40 locomotive No. 905 is shown at Venice, Illinois, on May 30, 1970. The GMO, also called the "Rebel Route," operated between 1940 and 1972, connecting the Gulf of Mexico at Mobile, Alabama, with Ohio, Indiana, Illinois, and west of the Mississippi River, to Kansas City. Under the management of Isaac B. Tigrett, the great-uncle of the cofounder by the same name of the Hard Rock Café, the GMO was a prosperous and extremely well-cared-for railroad at times when other railroads were struggling. In August 1972, the GMO merged with the Illinois Central (IC) to form the ICG.

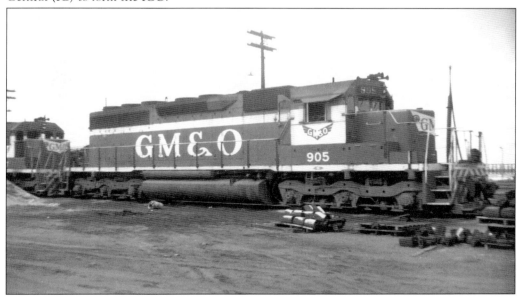

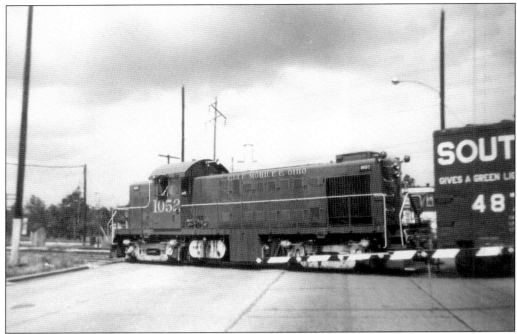

GMO RS-1 Locomotive No. 1052. These light road switchers with 1,000 horsepower were built by ALCO between 1941 and 1960. According to Jerry A. Pinkepank, all the RS-1 locomotives that were manufactured in 1941 were used in the war effort in the United States, in Russia, and in Iran. This one at Broadway in Venice, Illinois, on May 30, 1970, would have been built after 1943.

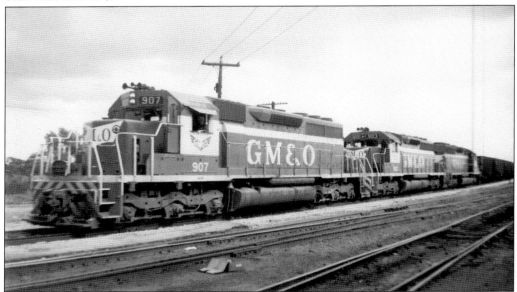

GMO SD-40 Locomotive No. 907. This SD-40 locomotive heads up a train with two other SD-40 locomotives including No. 903. The engines are pulling a Con Edison coal unit train through Venice, Illinois, on May 30, 1970. Con Edison provides electricity to Westchester County, New York, and to New York City.

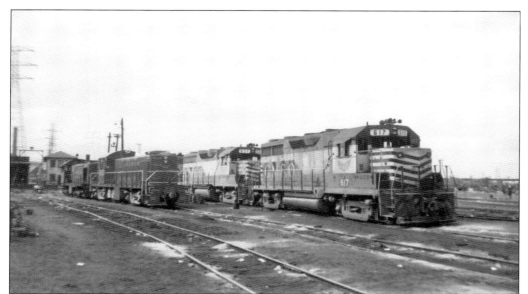

GMO GP-35 Locomotive No. 617. On the right, GP-35 locomotive No. 617 is followed by GP-35 locomotive No. 637. These were built by the EMD of General Motors. On the left, GMO RS-3 locomotive No. 1052 waits at Venice, Illinois, on May 30, 1970. The GMO yards were north of the Poplar Street Bridge and east of the city of East St. Louis, Illinois. The yards were close to the river and extended about a mile north and south along the top of the levee.

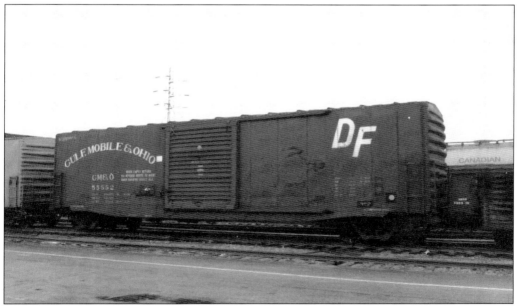

GMO Boxcar No. 55552. The GMO had a reputation for keeping its locomotives neatly painted and in good repair. The railroad is credited with developing specialized racks and cushioned under-frames for "damage free" boxcars, which were labeled with "DF" like this 50-foot boxcar with a single sliding door. The road name is painted white in GMO's characteristic arching reporting marks.

53

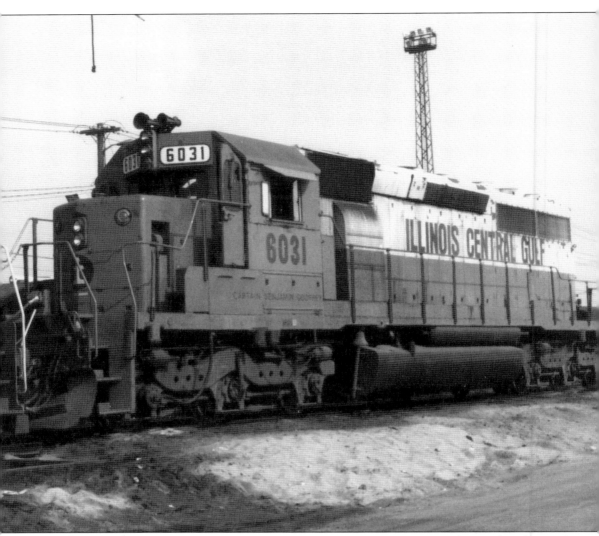

ICG SD-40-2 Locomotive No. 6031. ICG began operating in 1972 when IC bought GMO. This gave IC all of GMO's assets between East St. Louis, Illinois, and the Gulf of Mexico. The purchase agreement stipulated that the word "Gulf" would be added to the name of the railroad, hence the new ICG. In 1974, ICG assigned the names of 44 historical railroad personalities to its GP-38-2 and SD-40-2 locomotives. This SD-40-2 locomotive is named *Captain Benjamin Godfrey*. The Madison County town of Godfrey, Illinois, was named to honor this man who built the Chicago and Alton Railroad in 1852 to haul coal to Springfield, Illinois. The *Captain Benjamin Godfrey* SD-40-2 locomotive is shown in the ICG yards of East St. Louis on October 7, 1979. His name is painted in small type under the locomotive's cab window.

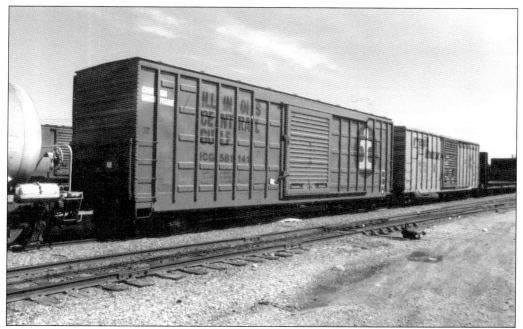

ICG Boxcar No. 581141. Waffle sides allow a 50-foot boxcar to support the inside devices that prevent loads from shifting during transport. This boxcar is shown on the MP tracks near Theresa Avenue in St. Louis in October 1978. The split dotted *i* herald of ICG occupies much of one side of the car.

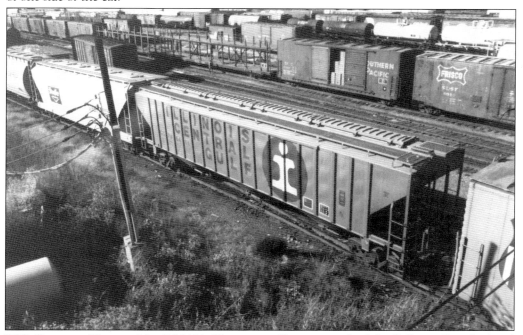

ICG Covered Hopper No. 766411. This covered hopper was built by Pullman Standard and is a PS-2. It is shown on the MP track in Mill Creek Valley from the Eighteenth Street Viaduct in St. Louis on October 15, 1978.

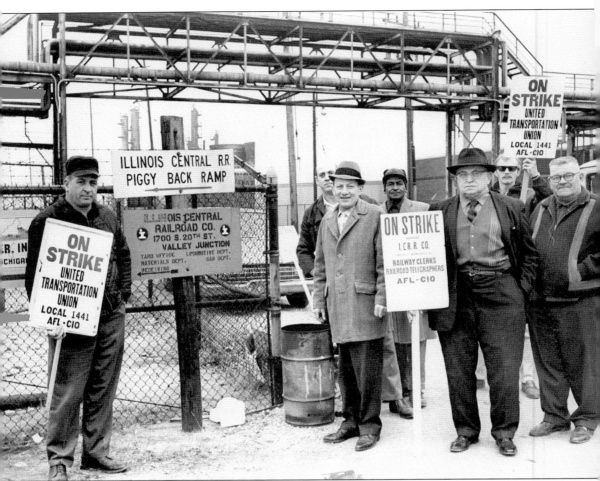

IC Railroad Strikers. IC, widely known as the "Main line of Mid-America," was the nation's largest railroad shipper of bananas, which were loaded onto their fleet of refrigerator cars from the docks in Mobile, Alabama, and New Orleans, Louisiana, beginning in the 1870s. This photograph of striking IC workers appeared in the *St. Louis-Globe Democrat* on December 10, 1970. The United Transportation Union Local 1441 AFL-CIO railway clerks and railroad telegraphers are picketing at the IC railroad yards at the gate at 1700 South Twentieth Street in the Valley Junction Terminal of East St. Louis, Illinois. (Courtesy of the St. Louis-Globe Democrat archives of the St. Louis Mercantile Library, University of Missouri-St. Louis.)

Illinois Traction Railroad Locomotive No. 2294. "The Road of Personalized Service" used the bold colors Brewster green and "traction orange" to paint its locomotives. Its wheels and under-frames were typically painted red. The railroad began as the Illinois Traction Railroad (ITC), a passenger operation that serviced Central Illinois at a time when smaller cities were connected by small railroads. The name of its freight operation, Illinois Terminal Railroad (also ITC), delivered newsprint paper into St. Louis for the *Globe Democrat* newspaper. This railroad ran on its own tracks between Danville, Illinois, and St. Louis, Missouri, where it entered over elevated tracks via the Merchant's Bridge at Eleventh Street and Tyler Avenue. After crossing the bridge, it traveled at ground level until around Delmar Avenue or Cass Avenue where it began to run below ground in a big ditch to the Globe Democrat newspaper building where there was a passenger station.

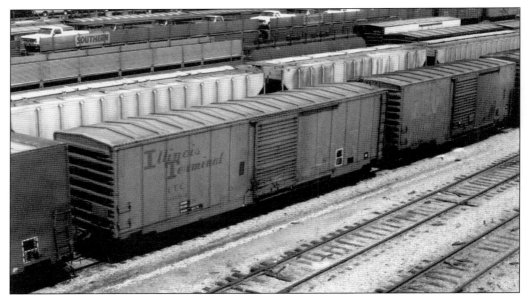

ITC BOXCAR NO. 9084. ITC was a leader in comfortable electric inter-urban passenger rail travel, but by 1956, the railroad was acquired by a group of 11 railroads operating in the St. Louis Gateway. By 1968, the railroad was nearly bankrupt. This 50-foot boxcar is shown in the Frisco Lindenwood yard of St. Louis in August 1978.

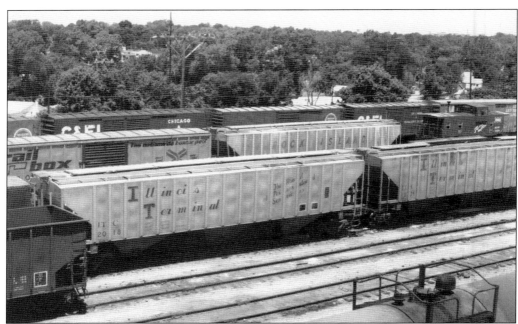

ITC COVERED HOPPER NO. 2018. E. B. Wilson became ITC's president in 1968. This visionary leader turned the railroad around by overseeing the acquisition of a new route, modern welded track, and a new fleet of freight cars. This Pullman Standard type of covered hopper is joined to ITC covered hopper No. 1836 in the Frisco Lindenwood yards. The photograph was taken from the Arsenal Street Viaduct in June 1978.

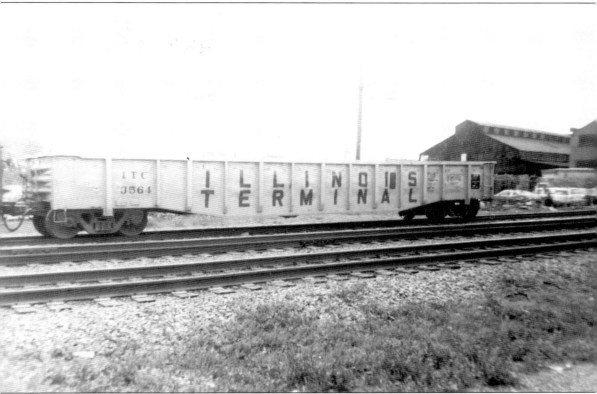

ITC Gondola No. 3564. ITC Gondola No. 3564 is shown on the MP storage track along Manchester Road in St. Louis on May 2, 1974. It is painted yellow, with green lettering, a red frame, and red trucks reflecting E. B. Wilson's aggressive optimism for the resurgence of this railroad. His leadership ended without realizing his goals when NW bought ITC on May 8, 1982.

ITC BULKHEAD FLATCARS. ITC's 60-foot bulkhead flatcar No. 1402 (above) is painted yellow. It is shown in the Frisco Lindenwood yards of St. Louis on September 13, 1979. Below, another yellow 60-foot ITC bulkhead flatcar, No. 4426, is shown in the Mill Creek Valley yards of St. Louis on October 15, 1978. The photograph was taken from the Eighteenth Street Viaduct showing a view of downtown St. Louis city. Above the tracks is the elevated section of Highway 40/64.

Kansas City Southern Covered Hopper No. 5129. Even though the Kansas City Southern (KCS) did not reach St. Louis and they did not have a freight house there, the cars were seen in St. Louis sometimes on the team track sidings. These team track sidings are scarce now but they were located east of Chouteau Avenue, west of Tower Grove Avenue, near Grand Avenue. There used to be a hub of 15 or more team tracks near the bakery there. KCS began in 1887 under the leadership of Arthur E. Stillwell. Unlike most of its early contemporaries, this railroad's objective was to connect Kansas City, Missouri, with Port Arthur, Texas, and the Gulf of Mexico. From 1940 to 1969, KCS operated luxury passenger service to New Orleans from Kansas City. This Pullman Standard–style covered hopper was used to transport flour loads. It was photographed at the Central Industrial Court of St. Louis in September 1978.

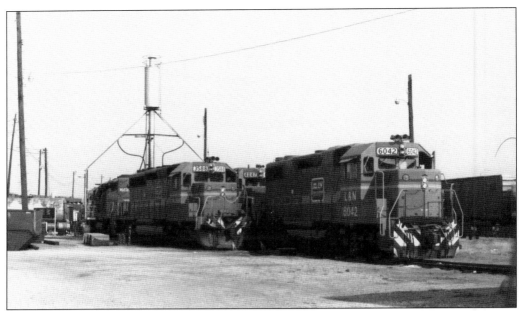

LN GP-38 Locomotive No. 3588. By 1971, LN, having bought the Nashville, Chattanooga and St. Louis Railroad and a piece of the Chicago and Eastern Illinois Railroad, was operating in 13 states. After 1970, the road's slogan changed to "Family Lines System" from two historic ones: the "Old Reliable" and the "Dixie Line." To get freight from its yards in East St. Louis, Illinois, to its storage shed on the north side of downtown St. Louis city near the river, LN relied on the switching services of the TRRA. Above, LN GP-38 locomotive No. 6042 is among the newly painted ones shown standing at the LN yards in East St. Louis on October 7, 1979. Below, LN GP-38-2 No. 4112 is shown there on the same day.

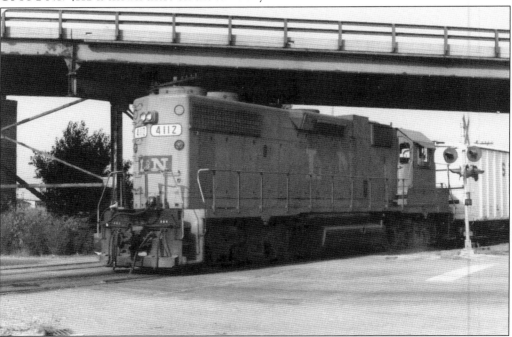

62

LN Caboose No. 6220. This bay window caboose, shown above, is next to LN caboose No. 6355 in the LN yards of East St. Louis, Illinois, on May 30, 1974. Below, an old caboose, SCL No. 01125, with a cupola, has been repainted and renumbered because, after 1971, LN became a subsidiary of the Seaboard Coast Line Industries. This is shown on the NW tracks at Theresa Avenue in St. Louis on September 24, 1979, three years before the company merged to form the Seaboard System Railroad.

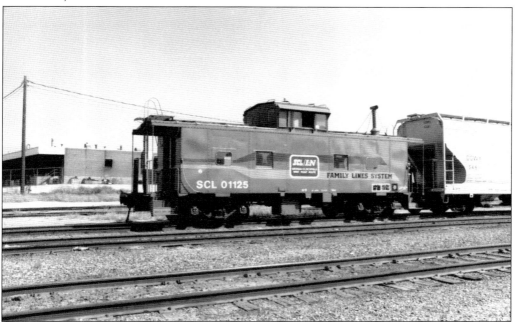

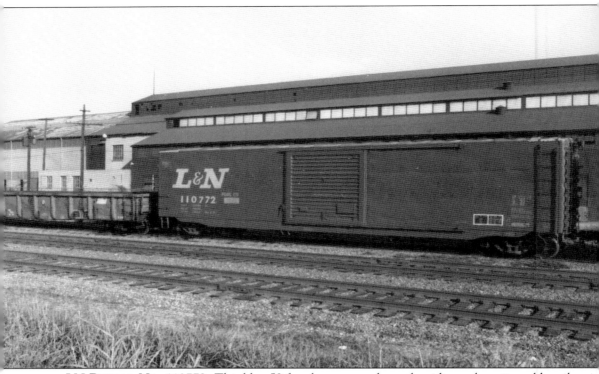

LN Boxcar No. 110772. This blue 50-foot boxcar stands on the siding, where it could easily be loaded or unloaded, next to the Scullin Steel Company on Manchester Road in St. Louis in August 1978. These MP tracks, after being removed to make room for a strip mall, were relocated to the south side of the property that used to belong to the Scullin Steel Company. The company produced munitions, railroad car under-frames, and the eponymous steam locomotive disc drivers. The normal arrangement provided two days for customers to unload or load a boxcar before being charged demurrage. Demurrage rates compensated the railroad for cars that were not in service. In 1965, according to the AAR, a railroad would charge customers a fee of 1.266¢ for each ton per mile. This boxcar, with a very wide single sliding door, probably has a capacity of 110 tons.

M&StL Cars. The M&StL ceased operations on November 1, 1960, so any cars that still carried this railroad's reporting marks in the 1970s had managed to escape being repainted with the new owner's (CNW) reporting marks. The M&StL was originally organized out of the Iowa Central Railroad in 1870 to haul grain between Minneapolis and St. Louis. It also serviced the cement and the meat packing industries. Above, an M&StL covered hopper is shown at the Central Industrial Court of St. Louis in September 1978. Below, a 50-foot M&StL flatcar No. 23883, with 110,000 pounds capacity, waits with an unusual load in the Frisco Lindenwood yard of St. Louis on April 13, 1979.

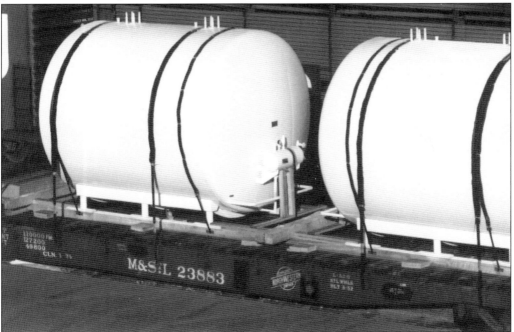

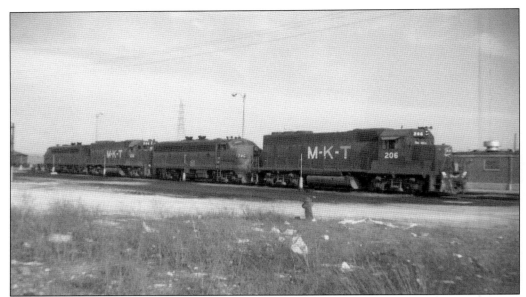

MKT LOCOMOTIVES. Above, the Missouri, Kansas and Texas (MKT), also called KATY, GP-40 locomotive No. 206 is shown on the point of the train and followed by GP-40 locomotive No. 208, MKT F-9 locomotive No. 74-C, and another F unit in the MKT yards at Hall Street in St. Louis. The GP-40 locomotives were built by the EMD of General Motors with 3,000 horsepower in 1968. The F-9 locomotive was built by the EMD of General Motors in 1955. The MKT originated as the Union Pacific (UP) Railway in 1865 with aspirations to connect Junction City, Kansas, with New Orleans and Chicago. By 1873, the railroad extended north from Sedalia through Hannibal toward Chicago. Another KATY main line connected Sedalia through Jefferson City to St. Louis. In 1979, only two daily MKT freight trains passed through St. Louis. Below, MKT locomotive No. 31 waits.

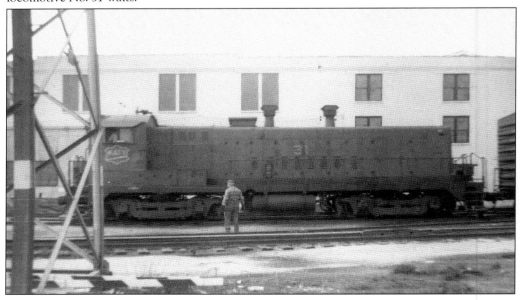

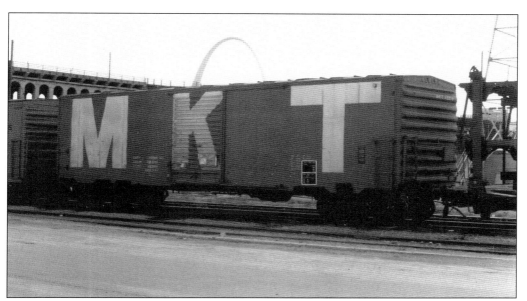

MKT BOXCAR NO. 92219. It takes an entire wall of this 40-foot boxcar to fit the road name painted white in huge block capital letters. The highway access to the MacArthur Bridge is shown above the car to the north and the Gateway Arch towers in the background.

MKT COVERED HOPPER NO. 9122. This covered hopper has the older KATY herald beneath the designation "airslide." Airslide hoppers have fabric linings between the car's exterior walls and the load. When air is forced between the car's liner and the wall, its granular load flows down to exit through the hatches in the lower bays.

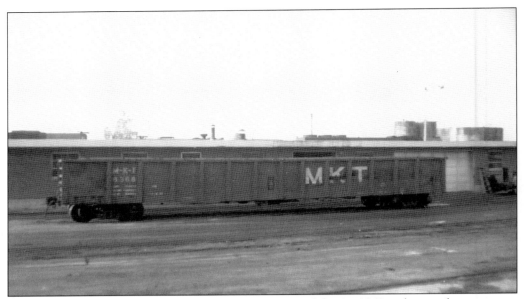

MKT GONDOLA NO. 8368. The rectangular MKT gondola No. 8368 is shown, above, next to the MKT terminal in St. Louis on October 17, 1971. Below, an MKT fish-belly gondola stands in the yard. MKT had maintenance yards in St. Louis city at East Grand Avenue and Hall Street just west of the CBQ yards. The railroad also had yards on the south side of the bend in the Mississippi River across the river from Venice, Illinois.

MP ENGINE FACILITIES. The MP, begun in 1849, the first railroad west of the Mississippi River, was considerably damaged during the Civil War. The costly 1869 decision to install standard 4-foot-8.5-inch-gauge track paid off after the St. Louis Eads Bridge, built in 1874, allowed transcontinental rail traffic through the St. Louis Gateway from the Atlantic Ocean to the far west. The railroad's 22-story home office in downtown St. Louis opened in 1928. MP continued to be an innovative voice for the industry. In 1970, its Containerpak system orchestrated the shipment of containers from trains to ships. In 1972, Missouri Pacific Airfreight began transferring air cargo collected at the rail terminal in St. Louis. In 1973, the railroad built a new automobile distribution center in St. Louis where new cars could be off-loaded from trains to trucks. In 1974, the MP began operating in Mexico to form the first rail connection between Canada and Mexico. The building shown here is MP's engine facilities in St. Louis city at Ewing Avenue and Papin Street.

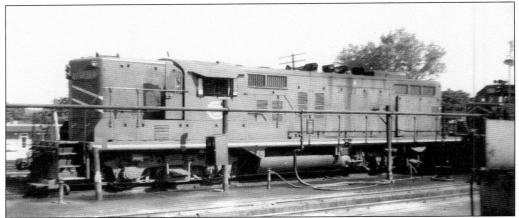

MP GP-7 Locomotive No. 1294. This GP-7 locomotive waits at the platform beside MP SD-40 locomotive No. 741 in Dupo, Illinois, on May 17, 1970. MP initiated a 1970 improvement program where it ordered 20 new diesel locomotives that were to be delivered by April. All of the new locomotives would be equipped with 3,000 horsepower. The railroad also purchased 1,000 additional freight cars: 400 boxcars each 60-feet long, 100 insulated boxcars, and 500 covered hoppers. The railroad's transportation center kept track of all the cars using computers at the headquarters in St. Louis. The senior project leader Wally Johnson wrote about how the railroad was using computer technology for *Mo-Pac News*, Volume 43, December 1969. He predicted that "eventually it will be possible to accurately forecast short-term car supply and demand, move rolling stock accordingly and thus anticipate customer needs."

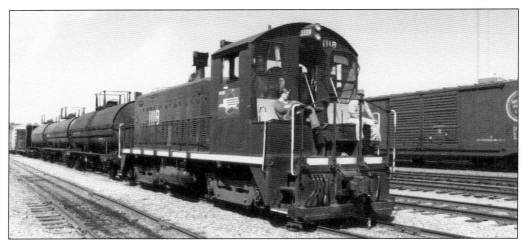

MP SW-1200 Locomotive No. 1118. In a typical day during the 1970s, MP ran 400 trains with a total of around 70,000 cars over track in 12 states. The railroad was so successful in every facet of the process of tracking and routing freight cars that, in 1975, it obtained a government contract to develop an automated freight car scheduling system for which it was paid $5.5 million. This EMD switcher locomotive with 1,200 horsepower pushes a line of tank cars near Theresa Avenue in St. Louis in October 1978. Although some SW-1200 locomotives were fitted with dynamic brakes, this one, like most MP locomotives, did not have one. Locomotives received maintenance services at the North Little Rock shop in Arkansas while freight cars were repaired and modified in DeSoto, about 40 miles south of St. Louis.

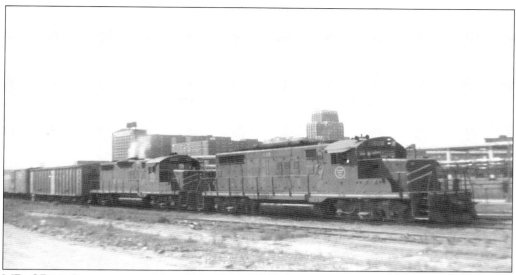

MP GP-18 Locomotive No. 509. This GP-18 locomotive heads the train followed by GP-18 locomotive No. 502 in August 1971. The tracks go east from the Mill Creek Valley and past the Gratiot Tower before heading over the MacArthur Bridge into Illinois. The following locomotive, No. 502, displays the bulge at the top of the hood to indicate the presence of a dynamic brake.

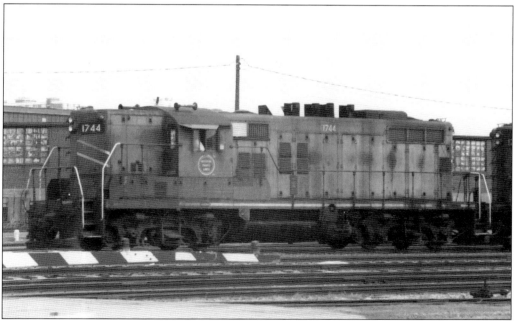

MP GP-7 Locomotive No. 1744. By the 1970s, these older GP-7 locomotives were used for switching and to power unit trailer-on-flatcar (TOFC) trains. Some engine parts could be serviced by opening the side panels. For more extensive maintenance, an overhead crane at a shop like the one MP operated for locomotives in Little Rock, Arkansas, removed the whole hood. This locomotive is shown waiting at a crossing on the Mill Creek tracks at Theresa Avenue in St. Louis.

MP GP-9 LOCOMOTIVE NO. 1726. The EMD GP-9 locomotives were more powerful than the GP-7 locomotives that preceded and resembled them. GP-9 locomotives had 1,750 horsepower. MP bought 40 new GP-9 locomotives in 1955. Painted blue and grey with yellow trim, they were repainted, starting in 1961, the unusual Jenk's blue, named after the railroad's new CEO, Downing B. Jenks. This locomotive is shown where the MP tracks pass over McCausland Avenue in St. Louis on March 12, 1979.

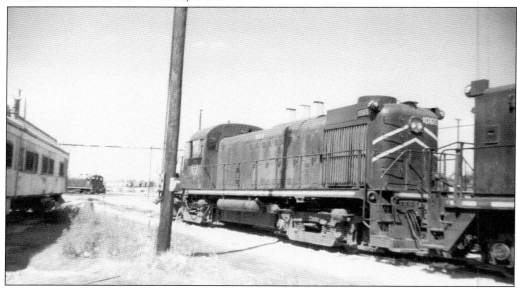

MP GP-12 LOCOMOTIVE NO. 1065. Although this locomotive was originally built by ALCO as an RS-3 locomotive with 1,600 horsepower, MP arranged for EMD to convert it, adding different kinds of fuel and air tanks, reclassifying it as a GP-12. It is shown waiting at the platform at the MP yards in Dupo, Illinois, on May 17, 1970.

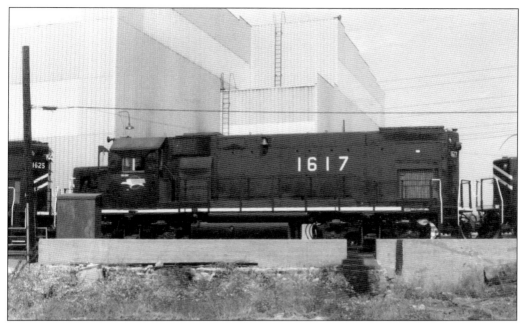

MP GP-15 Locomotive No. 1617. The MP locomotives Nos. 1555–1664 were specially converted so that the 12-cylinder engines would produce 1,500 units of horsepower. This one is shown, painted with the new flying eagle emblem in Jenk's blue, at the MP engine facility at Chouteau Avenue in St. Louis on October 8, 1979.

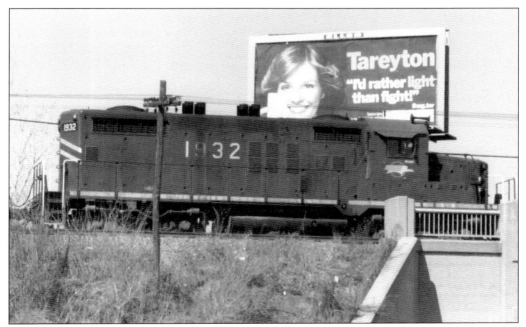

MP GP-18 Locomotive No. 1932. This locomotive was built by EMD. It has been painted Jenk's blue and flies the newest version of the eagle herald. It is heading west over the McCausland Avenue overpass in St. Louis just having passed the Scullin Steel Plant, on March 12, 1979.

73

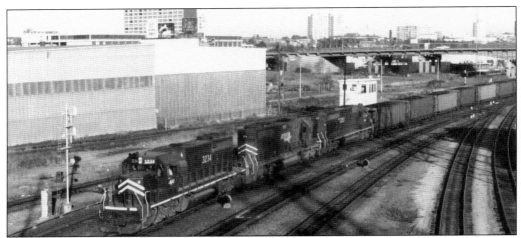

MP SD-40-2 LOCOMOTIVE NO. 3234. This SD-40-2 locomotive heads a unit train. It is followed by SD-40 locomotives No. 3087 and No. 3293. Both types of locomotive were built by EMD with 3,000 horsepower. The SD-40-2 locomotives are three feet longer and feature a larger platform on both ends of the engine. SD-40 locomotives were produced between 1966 and 1972. SD-40-2 locomotives began to be made in 1972. MP relied on SD-40-2 locomotives to haul pellets of iron ore from the mines and pellet processing plants in southeastern Missouri. The railroad had contracts to haul iron ore from two Missouri mines: Pea Ridge, which was jointly owned by Bethlehem Steel and St. Joseph Lead Company, and Pilot Knob. MP trains hauled three to four million tons of iron each year, which accounted for around three percent of the railroad's income. This train is shown running east of the Spring Avenue Viaduct in St. Louis on October 21, 1979.

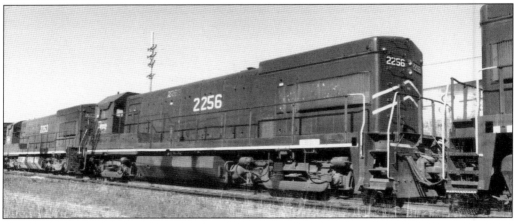

MP U-23-B LOCOMOTIVE NO. 2256. General Electric produced its first rail engine in 1897 to power a subway train. This General Electric locomotive with an EMD cab is seen from its rear end pulling locomotive No. 2253. The U-23-B locomotives operated with 2,300 horsepower and began to be built in 1968. MP owned 39 U-23-B locomotives in all. This one is shown on the MP tracks at Greenwood Avenue in Maplewood on October 13, 1979. Going west in St. Louis County, these tracks go through the municipalities of Webster Groves and Kirkwood before heading across the Missouri River en route, via Jefferson City, to Kansas City. MP's historic Kirkwood Station continues to service Amtrak passengers traveling from Kirkwood to downtown St. Louis and west, across Missouri. A second abandoned MP line splits to the northwest heading to Creve Coeur.

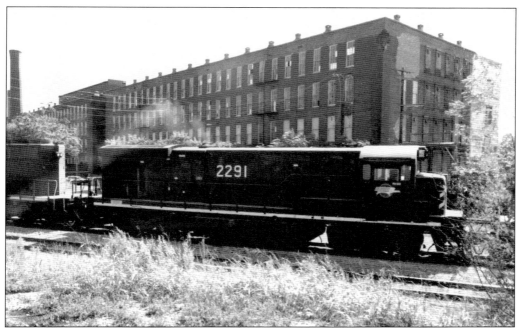

MP B-23-7 Locomotive No. 2291. The General Electric B-23-7 locomotives were designed for speed but not for hills. This locomotive, No. 2291, was one of the first 10 ordered by MP and was built in January 1978. Eventually the railroad bought a total of 30 B-23-7 locomotives. This one is shown, carrying the "bird in the buzz saw" herald, on the Frisco tracks at Central Industrial Drive in St. Louis in October 1978.

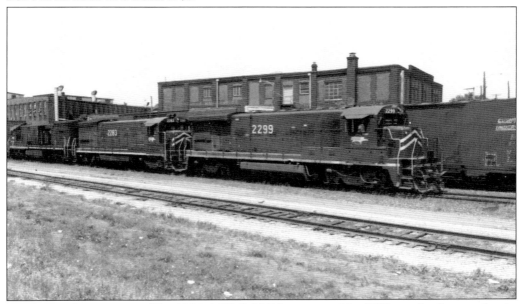

MP B-23-7 Locomotive No. 2299. MP's B-23-7 locomotive No. 2299 was the first number in the railroad's second order for 20 more B-23-7 locomotives that General Electric delivered and that were built in October and November 1978. It is followed by U-23-B locomotive No. 2283 at Central Industrial Drive in St. Louis on June 14, 1979.

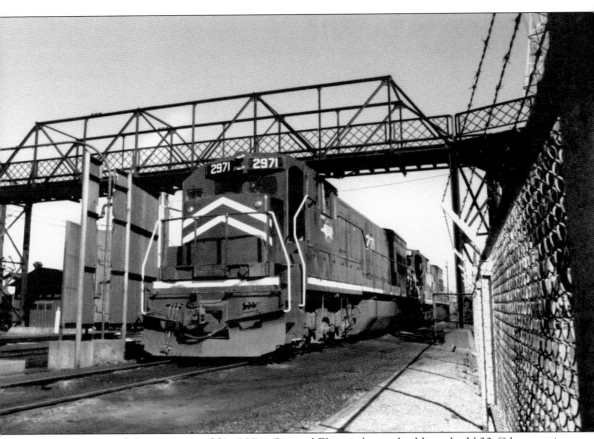

MP U-30-C Locomotive No. 2971. General Electric began building the U-30-C locomotives in 1967. These 67-foot-3-inch-long locomotives feature 16 cylinder engines that produce 3,000 horsepower as well as thick black exhaust. In 1969, MP purchased 29 U-30-C locomotives for pulling coal unit trains carrying as much as 12,000 tons of coal at once. The railroad hauled 4.5 million tons of coal in 1970, 15 million tons of coal in 1974, and 32.2 million tons of coal in 1980. Between 1969 and 1982, these powerful locomotives were renumbered four times. This locomotive is parked at the MP wash rack near Ewing Avenue and Papin Street near Chouteau Avenue in St. Louis in October 1978. The upturned white diagonal stripes and the lower trim are characteristic.

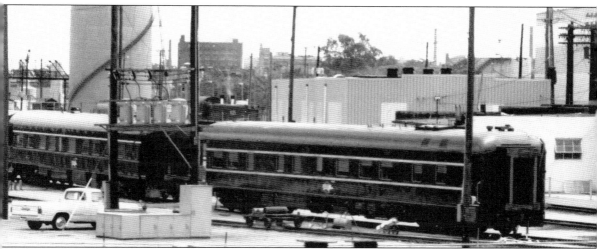

MP EXECUTIVE CARS. These blue domed passenger cars resemble the fleet of planetarium coaches built in 1952 for MP Railroad by the Pullman Standard Company. The MP headquarters was located at 210 North Thirteenth Street in downtown St. Louis city in the Missouri Pacific Building. This high-rise 22-story building was designed by architectural firm Mauran, Russell and Crowell in a neo-Gothic tiered style ornamented with pointed arches in 1928. The following year, two more floors were added. The building is on the National Register of Historic Places as the Union Pacific Building because it was renamed when UP purchased MP in 1982. These executive cars are spotted at the engine facilities near Jefferson and Chouteau Avenues in St. Louis on June 12, 1979.

MP Caboose No. 13403. This all-steel 31-foot-long caboose with a standard cupola and a tall smokestack was built between 1948 and 1950. It displays a large white buzz saw herald at Theresa Avenue in St. Louis in October 1978.

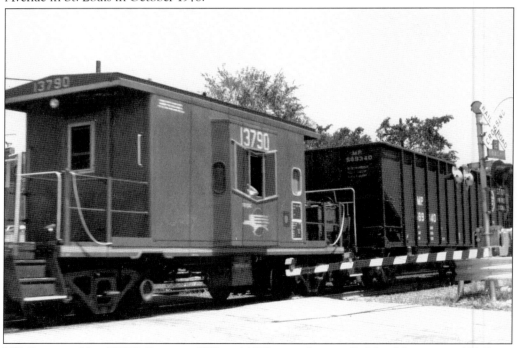

MP Caboose No. 13790. Between 1977 and 1982, at its shops at Sedalia, Missouri, and DeSoto, MP built 351 short cabooses that look like transfer cabooses. They cost between $40,000 and $50,000 each to build, according to Joe G. Collias. This caboose trails MP open hopper No. 589340 on the MP tracks at Ecoff Street in St. Louis in June 1978.

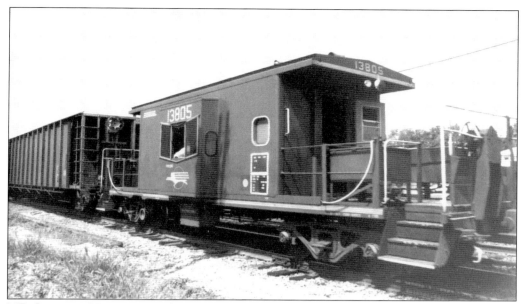

MP Caboose No. 13805. This is another of the short MP-designed and MP-built cabooses sometimes referred to as "doghouses." This caboose follows a covered hopper with the bird in the buzz saw herald under the cab window. It is shown on August 6, 1979.

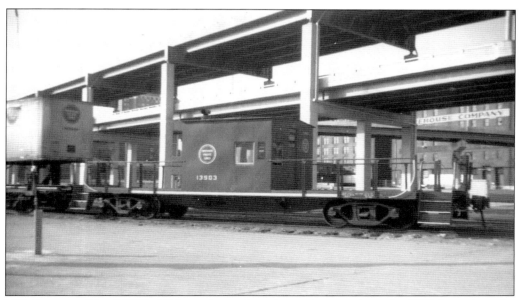

MP Caboose No. 13903. This steel transfer caboose is spotted on the TRRA track under Highway 40/64 in St. Louis on October 17, 1971. One MP elevated line went west of Tower Grove Avenue on the north side and can be seen from the viaduct or from Highway 40/64 where the railroad operated a passenger station and the controls for switches in the yards.

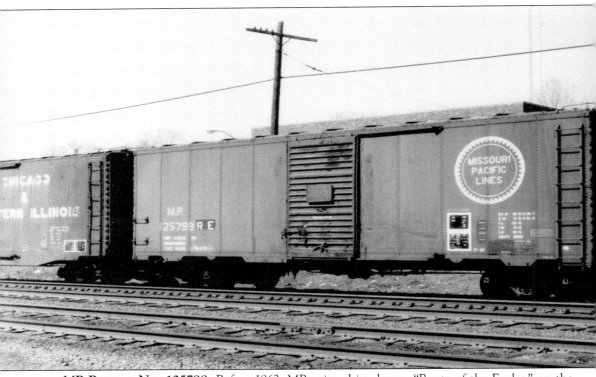

MP Boxcar No. 125799. Before 1962, MP painted its slogan, "Route of the Eagles," on the boxcars next to a small buzz saw herald. When the slogan was dropped, the railroad increased the diameter of the buzz saw emblem to five feet. Later a stylized eagle was incorporated into the buzz saw. It resonates in terms of public appeal. This 40-foot-long steel boxcar has a single sliding door and is next to a Chicago and Eastern Illinois boxcar. Chicago and Eastern Illinois was an independent subsidiary of MP until it became absorbed on October 15, 1976. This car has yet to be repainted with the MP reporting marks. The cars are shown at Manchester Road near Knox Avenue in St. Louis in March 1978.

MP BOXCAR. In the 1960s, the MP owned about 10,000 boxcars, NYC 20,000, and Rock Island about 15,000. The logistics of tracking this many cars without computers was daunting. This is the reason that the railroads painted the notations on the cars, "when empty return to" the point of origin. In the 1970s, MP developed a system-wide means of tracking cars using the newest computer technology at its North Thirtieth Street headquarters in downtown St. Louis. This end-loading boxcar is shown near the Nooter Plant located west of Second Street in St. Louis on September 11, 1976. A ramp, positioned over the railroad tracks, runs to the end door. There are two sliding doors on the side of the car as well, making it versatile for loading and unloading freight.

MP ART Reefer. The American Refrigerator Transit Company (ART) was set up as a partnership between the MP and the Wabash (WAB). ART operated cushion-sprung cars equipped with diesel refrigeration. In 1963, an MP 50-foot reefer cost $1,162 per carload of 140,000 pounds or 83¢ per 100 pounds to take a refrigerated load of goods from El Paso, Texas, to Memphis, Tennessee. This bright orange reefer is shown in Dupo, Illinois, on May 17, 1970.

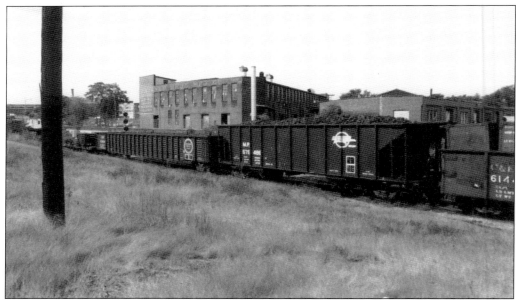

MP Open Hopper No. 575486. MP hoppers took coal from the mines in southern Illinois to one of the railroad's three intermodal rail-to-water docks where the coal was loaded from a tipple by conveyor belt to a barge for delivery up and down the Mississippi River. This hopper is parked at the Central Industrial Court of St. Louis in September 1978.

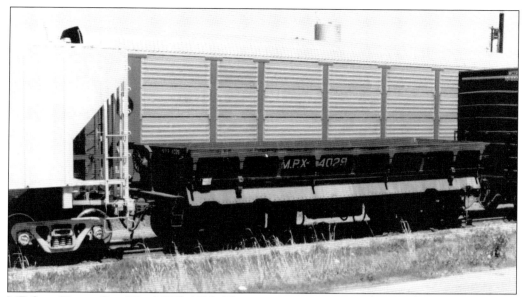

MP SIDE DUMP CAR NO. MPX 4029. This car is open on top with a fixed floor and movable sides. Railroads used this kind of gondola to move granite, coal, or ballast. This one is shown on the MP track at Industrial Drive in St. Louis on April 24, 1979.

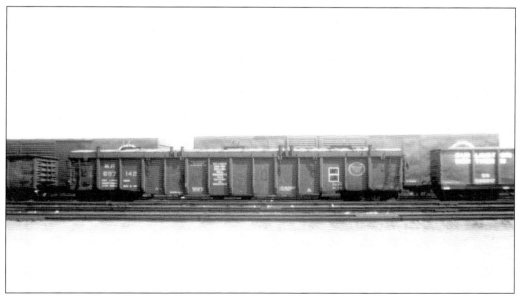

MP GONDOLA NO. 697142. This covered gondola with a fish-belly is 52 feet long and displays the buzz saw herald. The gondola was probably built in the 1950s with a capacity of 70 tons. It is shown in the MP yards at First Street in St. Louis on September 11, 1976.

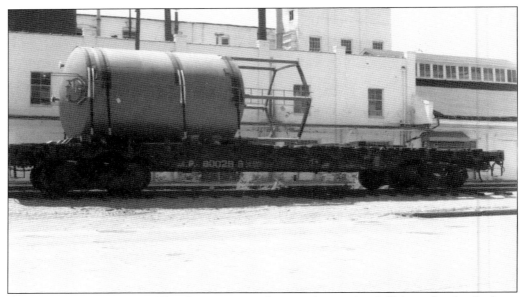

MP Flatcar No. 80028. This flatcar is part of a special train that MP formed to haul a large vessel from the St. Louis–based Nooter Corporation. The train was pulled by a GP-7 locomotive with a low nose. It is shown on South Broadway in St. Louis on May 25, 1977.

MP Automobile Rack. MP owned the tri-level automobile rack so the buzz saw emblem is lettered on the steel side near the end. This automobile car is enclosed to protect newly built automobiles from damage due either to weather or to vandalism. The automobile rack is mounted on top of a flatcar that the railroad leased from Trailer Train, which carries TTRX reporting marks. The automobile rack is shown in the Central Industrial Court of St. Louis in September 1978.

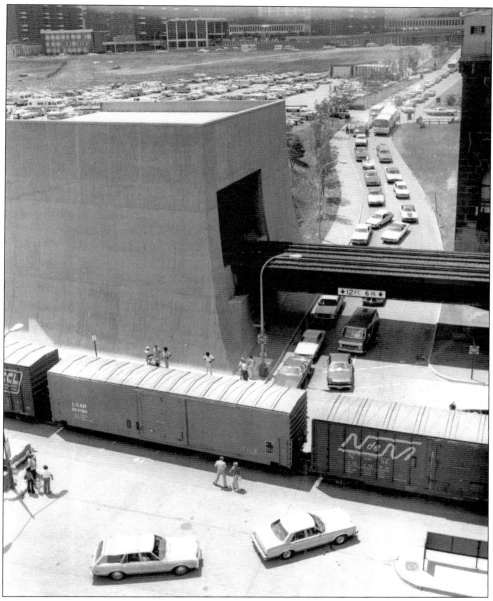

MP Train Stops Traffic. Some railroad incidents interfered with St. Louis traffic during the 1970s. On Sunday, July 2, 1978, this MP train, just south of the St. Louis Gateway Arch riverfront, stopped traffic for an hour. Cars backed up for one mile, and the City of St. Louis issued four tickets to MP for blocking an intersection. Behind the stalled train, tracks emerge from the tunnel leading from the Eads Bridge, behind the Gateway Arch, to the Mill Creek yards and Union Station. Only two months later, on September 7, 1978, seven cars derailed at South Broadway and Fillmore Street when a nine-year-old boy moved the switch. Four people were injured in that incident. On May 26, 1977, seven MP cars derailed at First and Market Streets at 4:00 in the morning on the way to Mitchell, Illinois. (Courtesy of the St. Louis-Globe Democrat archives of the St. Louis Mercantile Library, University of Missouri-St. Louis.)

NYC P&LE Gondola No. 42269. NYC became a "fallen flag" when the company combined with Pennsylvania to form the PC. That railroad went bankrupt on June 21, 1970, so even though NYC was the parent company of the Pittsburgh and Lake Erie (P&LE), these gondolas had escaped several opportunities to be repainted with the reporting marks of its new owners. Gondola No. 42269, above, is on the MP tracks near Tower Grove Avenue and Industrial Drive in St. Louis. Gondola No. 40279, shown below, is one of several similar gondolas on one train. Each carries a pipe load lashed to the top of its low sides.

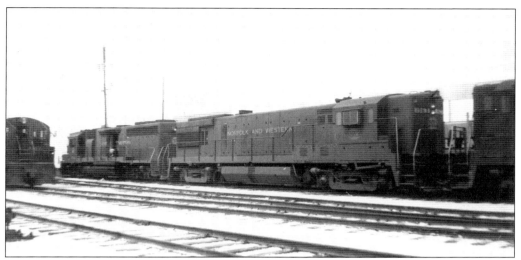

NW U-28-B LOCOMOTIVE NO. 1963. NW U-28-B locomotive No. 1963 is parked at the NW yards at Hall Street on May 30, 1970. It is followed by a GP-40 locomotive. The railroad was in the process of transitioning away from its historic role as a coal hauling railroad operating at first between Norfolk, Virginia, and Ohio.

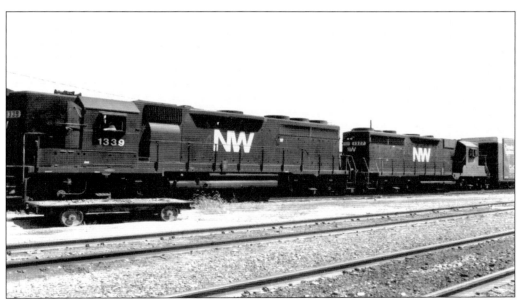

NW GP-40 LOCOMOTIVE NO. 1339. NW GP-40 locomotive No. 1339 is followed by GP-35 No. 1327 at Theresa Avenue in the Mill Creek Yard of St. Louis in September 1978. Both locomotives have high noses. By expanding extensively into the Midwest by buying other roads with routes to both St. Louis and Kansas City, the railroad soon grew to become a major player in the midwestern railroad scene.

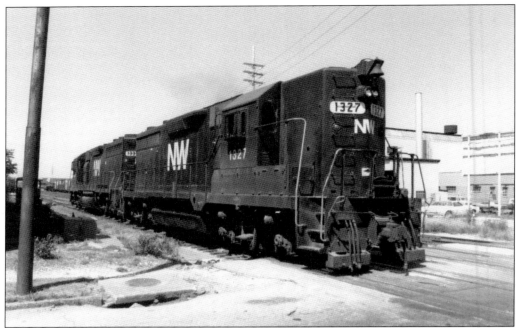

NW GP-35 Locomotive No. 1327. Above, GP-35 locomotive No. 1327 follows GP-40 locomotive No. 1339 at the Sarah Avenue crossing in St. Louis in September 1978. Below, NW SW-1200 locomotive No. 3364 is shown pulling a train at Theresa Avenue in St. Louis. NW went through several stages in the development of its locomotive paint schemes, beginning with dark blue in the 1960s. In the 1970s, the railroad used green, and after 1982, when Norfolk Southern formed, it changed to black. NW gradually obtained controlling shares in St. Louis railroads. In 1964, it gained the Nickel Plate and leased the WAB. By 1981, it obtained Illinois Terminal. The railroad used the A. O. Smith Yard in Granite City, Illinois.

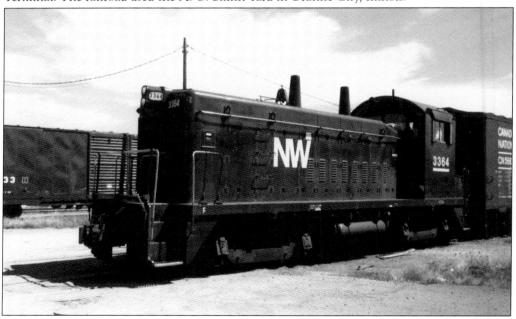

88

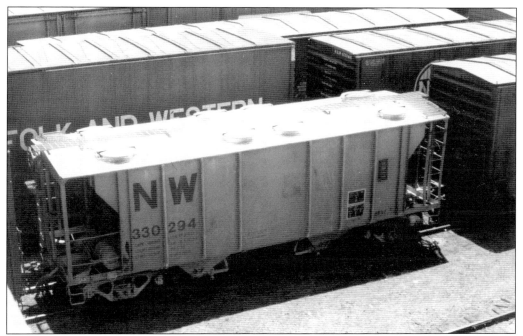

NW Covered Hopper No. 330294. This white two-bay covered hopper is parked in the Frisco Lindenwood yards in St. Louis. Eight roof hatches are used to load the hopper. It is unloaded from the two bays in the floor. The photograph was taken from the Arsenal Street Viaduct in June 1978.

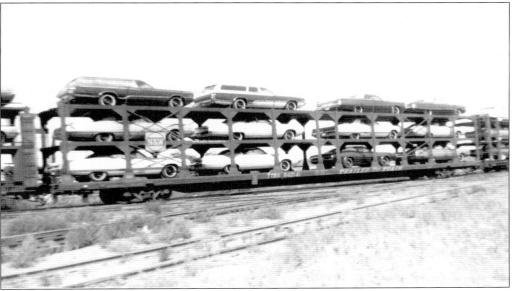

NW Automobile Rack. NW owned the tri-level open automobile rack that is mounted on Trailer Train flatcar No. TTRX 940141. This car carries 12 newly manufactured automobiles. According to the commerce department statistics for 1967, as reported by *MO-PAC News*, February 1970, Volume 43 No. 8, 58 percent of the nation's new cars, by weight, or 38.5 million tons, were shipped by rail.

PC Covered Hopper No. 890020. This PC PS-2-style covered hopper is shown in the Frisco Lindenwood yards of St. Louis. The Pennsylvania Railroad merged with NYC to form the PC in February 1968. The New York, New Haven and Hartford merged into PC later in the same year. Because the original railroads had each developed their own computer systems for signals, schedules, and tracking trains, the merger was complicated by compatibility problems as the industry adopted computerized business practices. Conrail took over the bankrupt lines of the PC after its formation in 1976. However, the Penn Central Company was not dissolved and continued to run some of its diversified non-railroad companies. Under its new owner, the American Financial Group, it still owns the New York City Grand Central Terminal.

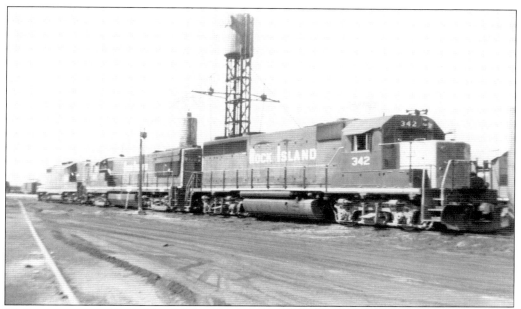

RI LOCOMOTIVES. Rock Island (RI and ROCK) is short for Chicago, Rock Island and Pacific Railroad, incorporated in 1847. In Missouri, RI ran on the north side of St. Louis to service the General Motors plant at Union and Natural Bridge before continuing along north of St. Charles to a line of small towns on the north side of Interstate 70. At Wentzville, the tracks cross to the south side of the highway to service the General Motors plant there. Below, RI SW-1 locomotive No. 530 is shown at the RI Carrie Street yards in St. Louis on April 29, 1972.

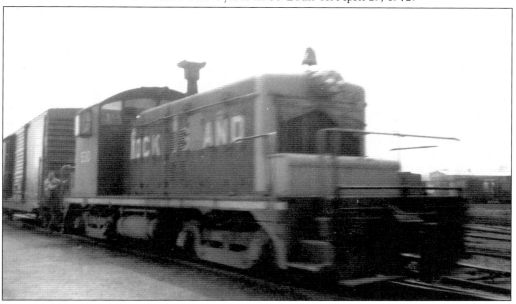

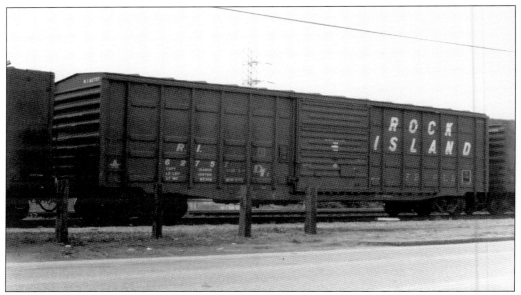

RI Boxcar No. 62757. This 50-foot boxcar with a wide single sliding door is painted boxcar red with white lettering. Early in the 1970s, RI made a serious attempt to modernize its image by changing to a bright blue paint scheme adorned by a new stylized hexagonal rock in the center of a capital *R*.

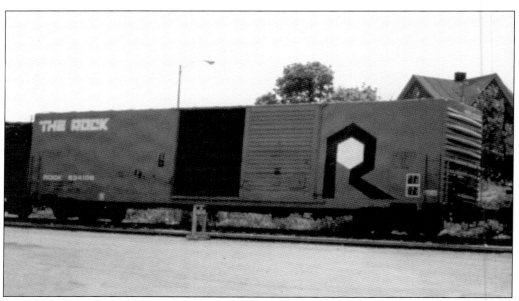

Rock Boxcar No. 534106. This blue 50-foot RI boxcar illustrates the railroad's new paint scheme and herald. Despite the new look, the railroad was unable to pull itself out of bankruptcy. In 1980, the Interstate Commerce Commission ordered the railroad to be liquidated.

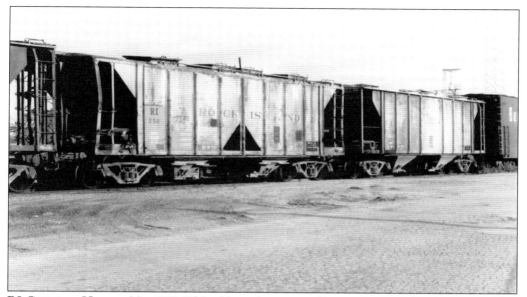

RI Covered Hopper No. 250. This old two-bay covered hopper is spotted in June 1977. This kind of car carried powdered loads like cement or flour. It loaded through the rectangular roof hatches and unloaded from the bays at the bottom.

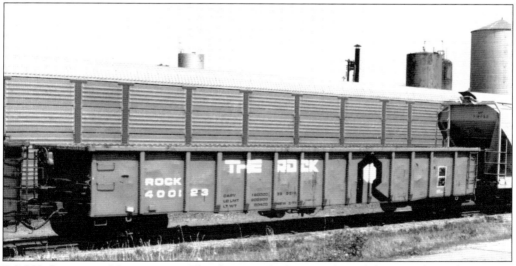

ROCK Gondola No. 400123. This beat-up, 50-foot, steel gondola on Industrial Drive in St. Louis on April 24, 1979, has been repainted blue. The Rock Island reporting marks have been changed to ROCK, and it carries the new rock herald. In August 1979, the clerks of Rock Island went on strike, and by early 1980, the railroad was ordered to liquidate by the bankruptcy court. Operations ceased in March 1980.

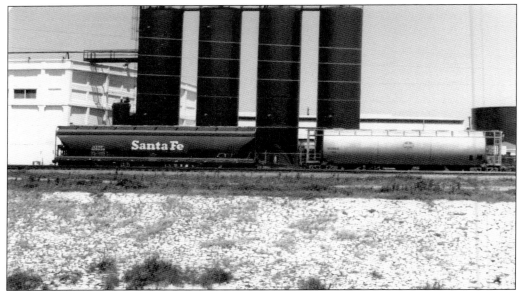

Santa Fe Covered Hopper No. 315030. This Santa Fe (SF) center-flow covered hopper is spotted at the Baroid Division of the National Lead Company by the River Des Peres at Macklind Avenue in May 1977. This company worked in the mud-drilling business for which the heavy metal barium was needed, and was usually moved in two-bay covered hoppers.

SF Airslide Covered Hopper. SF started in 1863 as the Atchison, Topeka and Santa Fe. David Atchison, the senator who was president for just one day, March 4, 1889, because Zachary Taylor refused to be inaugurated on a Sunday, was one of the railroad's founders. In the 1970s, SF developed a super hopper and other innovative solutions to move grain and potash through an intermodal delivery process. This covered hopper is shown from the Arsenal Street Viaduct of St. Louis in April 1978.

FRISCO ENGINE FACILITY. This view of the Frisco Lindenwood yards faces south from the Arsenal Street Viaduct on June 8, 1979. Frisco owned the Lindenwood yards that extend from the intersection of Arsenal Street and Jamieson Avenue about one third of a mile north along the River Des Peres to behind where the Scullin Steel plant used to be south of Manchester Road. The yard goes south to Wabash Avenue where the River Des Peres curves southwest.

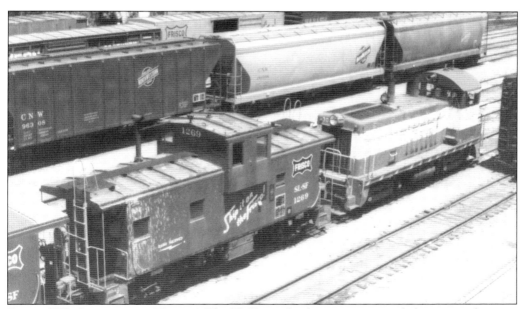

FRISCO SW-7 LOCOMOTIVE NO. 304. This EMD switcher locomotive is coupled next to wide-vision caboose No. 1269 in the Frisco Lindenwood yards from the Arsenal Street Viaduct in June 1978. The horizontal lightning bolt emblem designates that the caboose is radio equipped.

95

FRISCO GP-35 LOCOMOTIVE NO. 730. This EMD locomotive is followed by two other diesels. The F-9 locomotive No. 75 has a bulldog nose. The third locomotive is a U-25-B locomotive that was built by General Electric. The train is in the Frisco Lindenwood yards of Arsenal Street in St. Louis. From the Lindenwood yards, the Frisco tracks run along Watson Road until near Laclede Station Road where they turn south without crossing Laclede to near Valcour Avenue and then to Lindbergh Boulevard.

FRISCO U-25-B LOCOMOTIVE NO. 816. North of the yard, the Frisco tracks run along the River Des Peres east to Knox Street on the south side of the river. Then they run parallel to and south of the MP tracks east to Tower Grove Avenue. Between the two sets of tracks is a stretch of small industrial facilities.

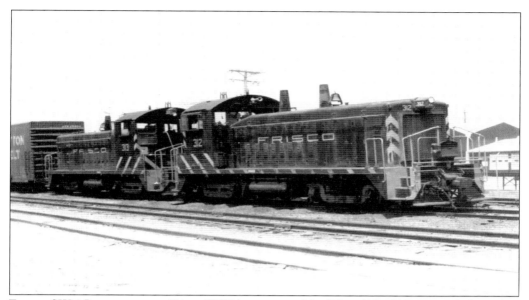

FRISCO SW-9 LOCOMOTIVES. Frisco SW-9 locomotives No. 312 and No. 313 are coupled together facing in opposite directions at Knox Avenue in St. Louis, just east of the Frisco Lindenwood yard in July 1977. EMD built the SW-9 locomotives between February 1951 and December 1953.

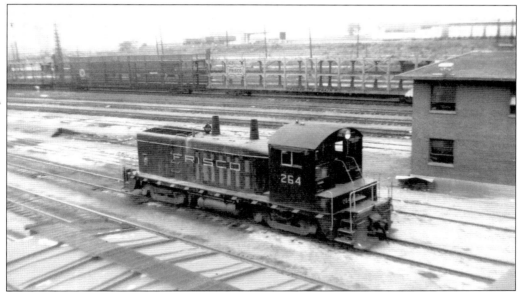

FRISCO NW-2 LOCOMOTIVE NO. 264. EMD sold 1,119 NW-2 locomotives built between 1939 and 1949 to American railroads. They use a 12-cylinder engine to produce 1,000 horsepower for switching. NW-2 locomotives with cabs like the one shown here are known as "cows." NW-2 locomotives without cabs added additional motive power, always followed a cow, and are called "calves." Across the yard there is an empty Frisco tri-level automobile rack.

FRISCO SW-1500 LOCOMOTIVE NO. 323. Frisco SW-1500 locomotive No. 323 pulls Frisco caboose No. 1268 over the River Des Peres, above, near Knox Avenue in St. Louis on May 9, 1979. Below, the train is shown at Industrial Drive on the same afternoon. The River Des Peres flows under St. Louis city from Vernon and Skinker Avenues through Forest Park where it was first forced underground through a wooden enclosed trough, for sanitary reasons, for the 1904 St. Louis World's Fair. Then it flows, open, south and a bit west, parallel to the Frisco Lindenwood yards until it meets the Mississippi River south of Carondolet within banks that were stone paved as a project of the Works Progress Administration. In 1973, it flooded heavily. This motivated the installation of levees funded by the residents whose property lay closest to the river south of Morganford Road.

Frisco Caboose No. 1724. This wide-vision caboose looks newly painted, red, with a white stripe and the black coonskin herald. It stands, spotless, in the Frisco yards of St. Louis near Southwest Avenue in September 1977. The bolt of lightning on the side designates that it is equipped with a radio.

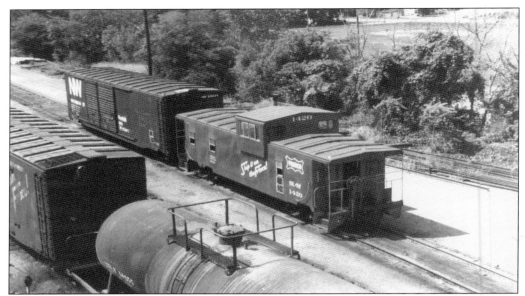

FRISCO CABOOSE NO. 1420. Both cabooses are shown parked in the Frisco Lindenwood yards. The wide-vision caboose No. 1420 stands next to a NW boxcar, above. Below, Frisco caboose No. 1244 stands next to a mostly empty gondola and Frisco boxcar No. 8559. The caboose displays the railroad's coonskin herald and the slogan "Ship it on the Frisco." This was the last slogan of the railroad that was chartered in 1849 to provide passenger service from St. Louis along John Fremont's trail to the California gold rush. The railroad never did extend west of the Rockies. Instead, it bought up lots of smaller railroads in Mississippi and Alabama until it was able to offer a very competitive passenger service from St. Louis to the Gulf of Mexico. It was bought by BN in 1980.

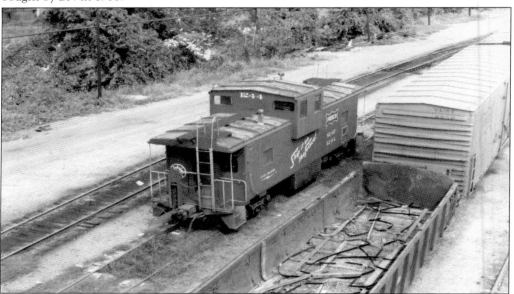

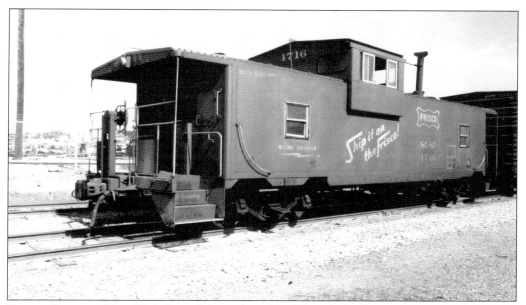

FRISCO CABOOSE NO. 1716. One of the early railroads bought by Frisco in 1876 was the Pacific Railroad of Missouri, which had been so heavily damaged during the Civil War that it went bankrupt. Frisco had projected that it would extend through the southwestern United States, but it was unable to build west of Tulsa, Oklahoma, until after 1880 because of the opposition of the Cherokee Nation.

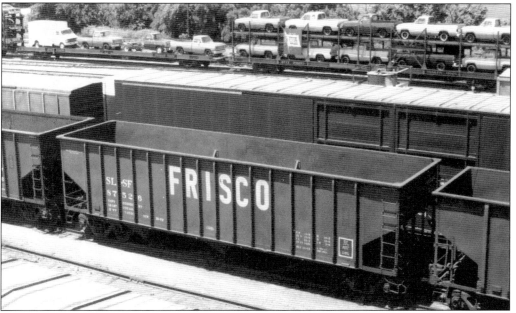

FRISCO OPEN HOPPER NO. 87526. Frisco added additional lines by buying smaller railroads built to service the iron mines in southern Missouri. Like the MP, Frisco serviced the glass and the lead industries along the Mississippi River, south of St. Louis, in Herculaneum and Crystal City. This open ribbed hopper with three bays is shown in the Frisco Lindenwood yards from the Arsenal Street Viaduct of St. Louis in June 1978.

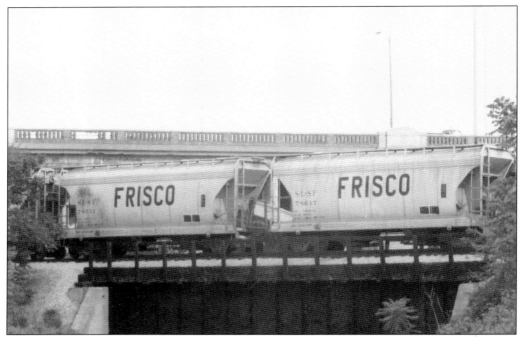

FRISCO COVERED HOPPER NO. 78551. ACF Industries built both of these two-bay covered hoppers No. 78551 and No. 78617 that are shown crossing over the River Des Peres near Knox Avenue in St. Louis on May 9, 1979. The river is mostly underground but, after a storm, the banks can be quite full of water. Then the odor is palpably that of a sewer.

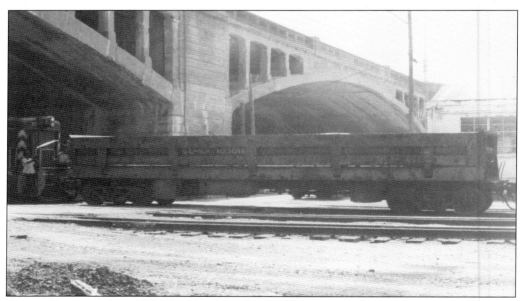

FRISCO GONDOLA NO. 103016. This old-style gondola with straight sides is shown with a work crew near the Kingshighway Viaduct. The Frisco tracks continue east, crossing the MP tracks, and lead to an industrial area near the McRee Town neighborhood where both the Krey Packing Company and Liggett and Meyers' cigarette factory used to be.

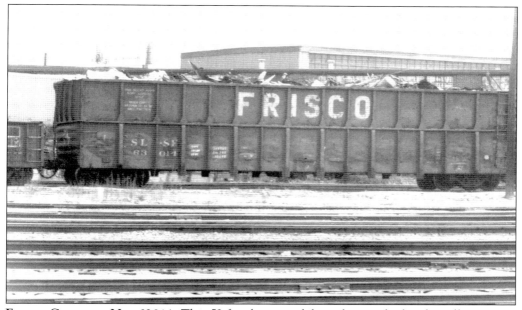

FRISCO GONDOLA NO. 63014. This 52-foot-long gondola with extra-high side walls carries a load of scraps. The car has an old paint job, boxcar red with yellow lettering. It is shown on the MP track at Theresa Avenue in St. Louis on June 5, 1979.

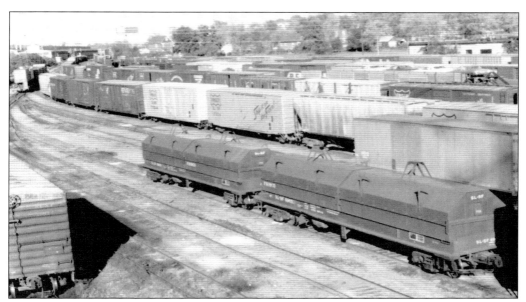

FRISCO STEEL COIL CARS. Two steel coil cars are between flatcars loaded with piggy back truck trailers in the Frisco Lindenwood yards of St. Louis. The Arsenal Street Viaduct is in the background. To the left of the solitary boxcar, out of sight down the hill, is the River Des Peres.

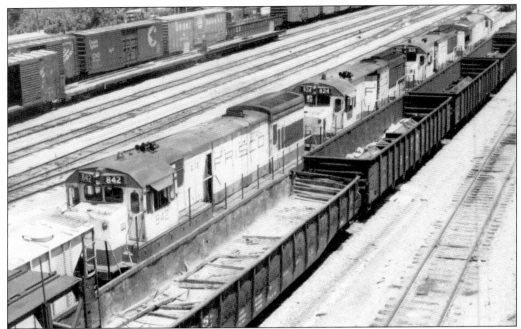

FRISCO LOCOMOTIVES AND GONDOLAS. Four locomotives built by General Electric stand on the track next to a line of empty Frisco gondolas in the Lindenwood yards in June 1978. The photograph was taken from the Arsenal Street Viaduct. Locomotives No. 824 (renumbered BN No. 5227) and No. 826 are U-25-B locomotives. Locomotives No. 842 and No. 864 are U-30-B locomotives.

FLATCAR FOLLOWING A GONDOLA. This flatcar carries an unusual load behind a gondola on an overpass crossing the River Des Peres near the Frisco Lindenwood yards.

FRISCO BULKHEAD FLATCAR. This 60-foot-long flatcar with bulkhead ends is loaded with cut lumber that is tied down. It is parked in the snowy Frisco Lindenwood yards near Southwest Avenue in St. Louis in February 1979. It follows a boxcar that displays the "Ship It On The Frisco" slogan that replaced the older slogan "Southeast Frisco Fast Freight Southwest."

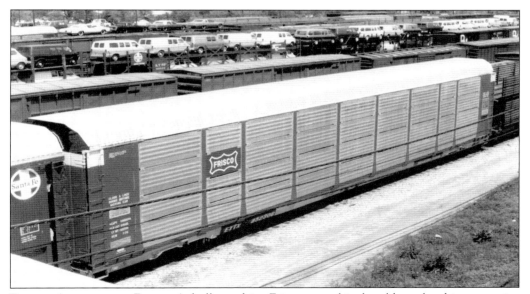

FRISCO AUTOMOBILE RACK. A hollow white Frisco coonskin herald marks this protective automobile cover as the property of the railroad. It is mounted on a leased flatcar, No. ETTX 852306. In the background several loaded older open-side tri-level automobile racks are parked. One carries 12 cars; the other carries 15 vans.

105

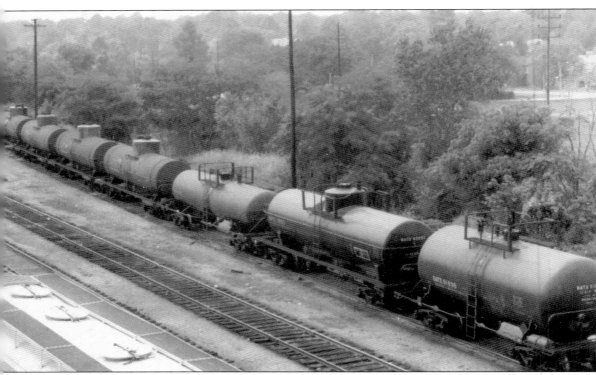

FRISCO TANK CARS. This line of assorted tank cars is headed by four Frisco tank cars with large yellow domes. This line of single-dome tank cars is shown on the rip track of the Frisco Lindenwood yards in St. Louis in October 1977. The first railroad tank cars were wooden tanks mounted on flatcars to service the Pennsylvania oil fields in 1865. In the early 1900s, the railroad industry developed standards for tank cars, and by the 1930s, 103 liquids other than oil were moved in railroad tank cars. A large variety of specialty tank cars exists. Some maintain the cargo at a specific pressure. Others regulate the temperature in the tank. There are tank cars with only one dome, others have up to six domes. Some have an elaborate external frame system while others feature only a narrow walkway around the dome on top. Tank cars come with lengths of between 30 and 65 feet with their specified capacity clearly marked on the outside of the car.

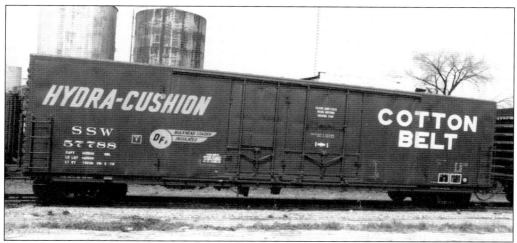

SSW Boxcar No. 57788. The St. Louis Southwestern (SSW), the "Cotton Belt Route," formed in 1891, went south from St. Louis through Arkansas and Texas in competition with the MP. The two railroads were joint owners in the bridge across the Mississippi River in Thebes, Illinois. Like MP, the Cotton Belt headquarters building was in downtown St. Louis city near the intersection of Locust and Olive Boulevards. Acquired and managed as an independent subsidiary by the Southern Pacific (SP), the Cotton Belt became absorbed into SP in 1977. SSW boxcar No. 57788 is 50 feet long and features a plug door. It is shown on the MP tracks at Central Industrial Drive in St. Louis on April 16, 1979. Below, the 50-foot SSW boxcar No. 23761 with a super wide plug door is parked in the Frisco Lindenwood yards on April 8, 1974.

107

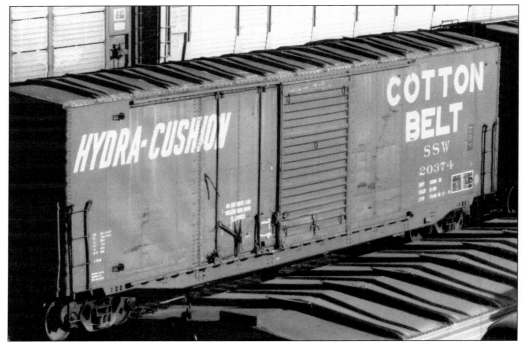

SSW BOXCAR NO. 20374. Cotton Belt painted the words "hydra-cushion" on the sides of these 50-foot-long boxcars to indicate that they were equipped with specialty under-frames to protect the load from being damaged en route. SSW boxcar No. 2037 has two doors: a plug door and a sliding door. It is parked in the Frisco Lindenwood yards of St. Louis on April 9, 1974.

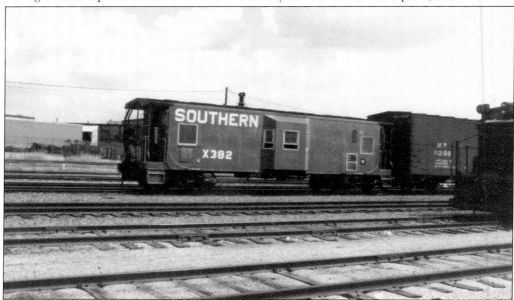

SOU CABOOSE NO. X382. The Southern (SOU) Yard was on the east side of the Mississippi River in East St. Louis, Illinois. SOU operated a line through Belleville, Illinois, to the river where it owned a passenger depot and a freight terminal. This bay-window caboose is shown at Theresa Avenue in the Mill Creek Yard in St. Louis on August 8, 1979.

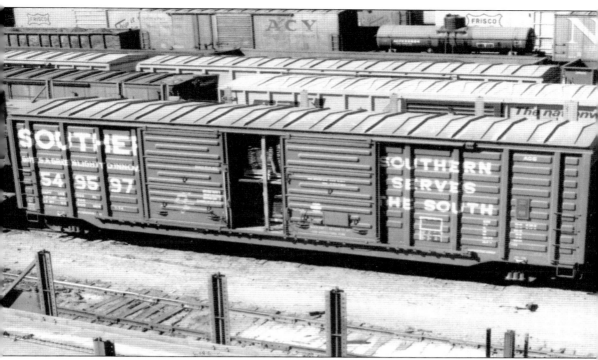

SOU Boxcar No. 549597. This waffle-side boxcar is parked with its sliding door open, revealing its load. Both slogans, "Southern Serves the South" and "Southern Gives a Green Light to Innovation," are painted in bold white block letters. SOU was the first railroad to carry military troops, to schedule steam trains, to operate at night, and to totally dieselize its locomotive roster.

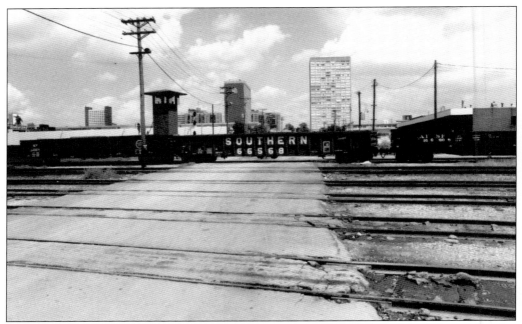

SOU GONDOLA NO. 66568. Sandwiched between an MP gondola and an SF gondola, this 50-foot-long gondola is crossing the intersection on NW tracks at the Mill Creek Yard in St. Louis on August 8, 1979. One letter only, painted in block white capitals, is between each of the car's ribs.

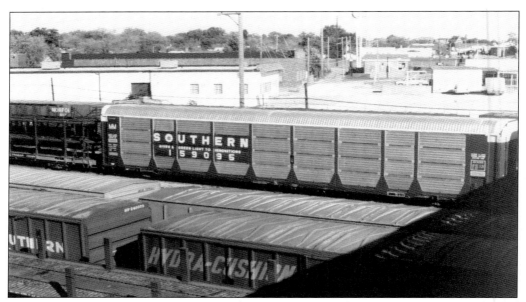

SOU AUTOMOBILE RACK NO. 159095. The protective cover bears SOU reporting marks and the slogan "Southern Gives a Green Light to Innovation" with the *o* in Southern filled in like a green light. The car is shown at the Frisco Lindenwood yards of St. Louis.

110

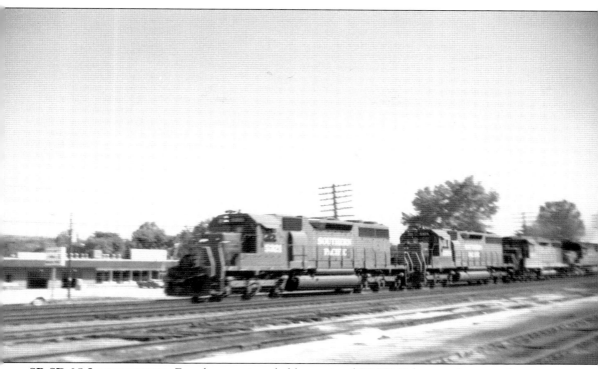

SP SD-35 Locomotives. Four locomotives, led by a trio of SP SD-35 locomotives, are shown in Dupo, Illinois, on May 17, 1970. Until SP bought the Cotton Belt in around 1955, it did not reach St. Louis at all. The original 1868 charter of the SP allowed it to run south from San Francisco, California, to El Paso, Texas, via Arizona and New Mexico. It continued to expand until it reached New Orleans in 1883 after buying the Atchison, Topeka and Santa Fe to become the second transcontinental railroad. Between 1955 and 1977, the Cotton Belt functioned as a tax shelter for SP because, in the state of California, tax on a railroad is figured by how much equipment is physically located in California on January 1. So the railroad swapped the SP rolling stock, which was chartered in California for the Cotton Belt rolling stock, which was chartered in St. Louis at that time of year.

UP U-28-C Locomotive No. 2807. UP locomotives still boast an early paint scheme with an Armour yellow body topped with light grey and red trim. UP, the first transcontinental railroad, received its charter in 1862 and reached its goal in 1869, the recipient of large federal land grants and loans. UP has consistently been a large, very well-run, and well-managed railroad, expanding by buying other railroads. Even years before its 1988 merger with the MP, UP cars were frequently seen in St. Louis. The UP had contracts with WAB, MP, and CNW to bring passenger cars, destined for St. Louis, from UP terminals in Denver, Colorado; Salina, Kansas; Kansas City, Missouri; and Omaha, Nebraska. This U-28-C locomotive, built by General Electric, is shown at Ewing Avenue in St. Louis in September 1978.

UP BOXCAR NO. 517588. Two UP boxcars, No. 517588 and No. 517599 are shown crossing over the River Des Peres near Knox Avenue in St. Louis on May 9, 1979. The cars feature double plug doors and display the red, white, and blue American flag shield herald.

UP COVERED HOPPER NO. 20660. This UP 50-foot air-slide grain hopper was built by General American to convey bulk shipments of grain or other granular or powdered substances. This one is shown on Manchester Road in St. Louis on June 6, 1979.

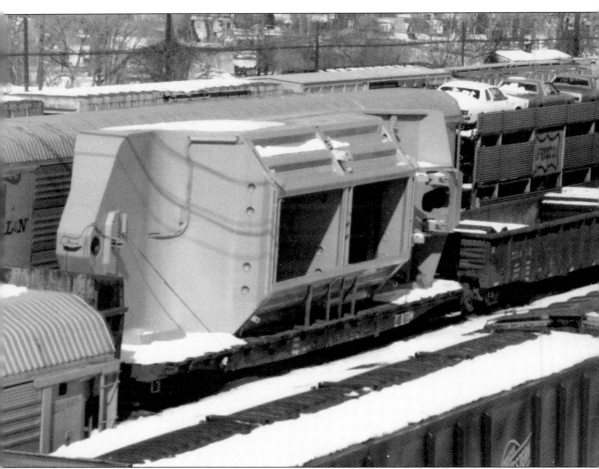

WAB FLATCAR NO. 70531. This 60-foot-long WAB flatcar and its open load are shown in the Frisco Lindenwood yards of St. Louis in February 1979. WAB was the first railroad to offer a trailer-on-flatcar service to carry van trailers piggyback, in 1954, a service that revolutionized intermodal rail to trucking freight operations. However, the railroad that crossed the Mississippi River from Alton, Illinois, to St. Charles, Missouri, bypassing the St. Louis Gateway on its route from Detroit to Kansas City, had a bad history of financial setbacks. Twice WAB was owned by Pennsylvania. Leased in 1960 by NW, by March 31, 1970, it was entirely owned by NW. After the 1904 World's Fair in St. Louis, the railroad operated within the city limits and owned Wabash Station on Delmar Boulevard near the western city limits. It was one of the few railroads to operate Fairbanks Morris–built steam locomotives, which used opposing rather than in-line cylinders in the engines.

Three

Non-Railway-Owned Cars Seen in the St. Louis Gateway

Many companies leased railroad cars so that they could be dedicated to and customized for hauling its products. This is especially important to chemical and liquid food producers who sometimes need to install particular liners in the tank cars or who want to insure against lethal combinations resulting from poorly cleaned tanks. Sometimes the benefits of advertising the company's herald and information painted on a dedicated train car is also a factor in motivating a non-railway owner to lease or to purchase cars. The Armour meat packing company had a very large refrigerator car fleet, which they painted a yellow known to railroaders as Armour yellow. It got to the point where any yellow railroad car was assumed to be a refrigerator car because the other railroads and the packing companies painted their refrigerator cars yellow too, although Swift painted their refrigerator cars with aluminum paint to reflect the sun off of the cars. Other companies like the Anheuser-Busch Brewery in St. Louis, the Peabody Coal Company, or the Weyerhauser Corporation relied so heavily on the railroad that they launched their own rail subsidiaries.

According to the 1973 edition of the *Rand McNally Handy Railroad Atlas of the United States*, 60 American companies owned, operated, or leased more than 300 railroad cars each. These included three from the St. Louis Gateway: Shippers Car Line of St. Charles, which was a division of ACF Industries, Incorporated; American Refrigerator Transit Company of St. Louis; and Monsanto Company of St. Louis.

SCULLIN STEEL PLANT. Above, the long mill buildings of Scullin Steel, founded in 1899 as the Scullin-Galligher Iron and Steel Company by John Scullin the president of the Union Depot Railway Company, is shown across Manchester Road from its headquarters. This large steel manufacturing plant near the western boundary of St. Louis city first made frames and undercarriages for railroad cars. During World War II, Scullin Steel produced elephant bombs for the British Royal Air Force. By the 1970s, under the ownership of St. Louis–based Diversified Industries, Incorporated, the company was one of the area's largest employers of African Americans. Concurrent with the decline in orders for railroad cars, wild-cat strikes and other labor union disputes impacted the company during the 1970s. By 1981, the company that stretched out on the south side of the MP tracks closed. Below, Scullin Steel Company EMD locomotive No. 6 is next to the plant.

ACFX Covered Hopper No. 47339. ACF Industries was the fourth largest employer of St. Louisans in 1978, according to historian William Faherty, SJ. Its Shippers Car Line Division headquartered in St. Charles owned 36,000 covered hoppers and tank cars among other railroad cars available for lease in 1978. ACFX covered hopper No. 47339, from the leasing pool, stands next to Proctor and Gamble on East Grand Avenue in St. Louis in June 1977. In 1973, ACF owned 34,795 freight cars, according to the *Rand McNally Handy Railroad Atlas of the United States*.

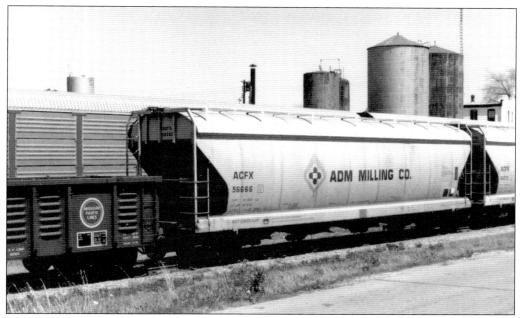

ADM Leased Covered hopper. ADM Milling Company leased this covered hopper from ACF Industries with the rights to mark the car with the company's logo and name even though it carries ACF reporting marks. ADM Milling Company is based in Decatur, Illinois, and is a large processor of soybeans, corn, wheat, and cocoa. ADM ACFX covered hopper No. 56666 is shown on Industrial Drive in St. Louis on April 24, 1978.

117

BAROID COVERED HOPPER. This air-slide covered hopper was leased to Baroid and probably carried a powdered form of the heavy metal barium, used in paint, x-rays, rat poison, and fluorescent lamps. BONX Air-slide covered hopper No. 104 is shown on the Frisco landing by the National Lead Company on Manchester Road near Macklind Avenue in St. Louis in March 1978.

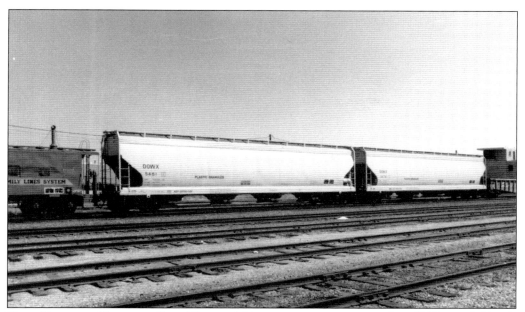

DOW COVERED HOPPERS. Dow Chemical Company was incorporated in 1897 to sell bleach commercially. It has become a leader in science and technology with an array of chemical, plastic, and agricultural products. These long four-bay covered hoppers labeled to carry plastic granules, were built by ACF and display DOWX reporting marks No. 5461 and No. 5474. They are shown on the NW track at Theresa Avenue on September 24, 1979. According to Rand McNally, Dow Chemical Company owned 1,299 freight cars.

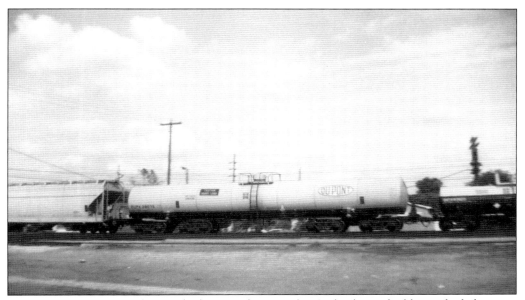

DUPONT TANK CAR. This single-dome tank car with 16 wheels on double trucks belongs to the DuPont Company. It displays DUPX reporting marks. DuPont, started in 1802, became the nation's leading supplier of gunpowder by 1820. Since 1880, the company branched out to become a significant leader in plastics, developing cellophane, Freon, nylon, Teflon, and Dacron.

119

GUEX COVERED HOPPER NO. 75280. General American Marks Company does business as GATX Corporation and used to be called the General American Transportation Corporation. It is based in Chicago, Illinois. Doing business since 1898, the company was the nation's leading leaser of railroad cars in the 1940s. In 1973, it owned 61,415 freight cars. This leased covered hopper has five bays.

GUEX NO. 75186. The AAR recognizes GATX, GAEX, GUEX, and GETX as reporting marks that belonged to the General American Transportation Company during the 1970s. Today they belong to the General American Marks Company. This five-bay covered hopper is part of a unit train headed for the Union Electric Plant in Labadie. It is shown beside the Scullin Steel Company on Manchester Road in St. Louis in July 1977.

MASX BOXCAR NO. 1020. This "all door" boxcar is owned by Masonite, the company originated to market the boards formed by William H. Mason's process out of pressed and heated wood chips. Doors comprise the entire side walls of the boxcars known as "Thrall All Door" boxcars. The doors facilitate loading, and the boxcar kept the boards dry. This car is shown on the MP tracks by Manchester Road in St. Louis on October 17, 1971.

MONX TANK CAR NO. 203. Monsanto was founded in 1901 to market its new product, saccharin. In the 1960s, it became famous for its herbicides; Roundup was first produced by Monsanto in 1976. The St. Louis–based company owned 1,400 freight cars in 1973 according to Rand McNally. This tank car is on the MP tracks at Manchester Road in St. Louis in June 1978.

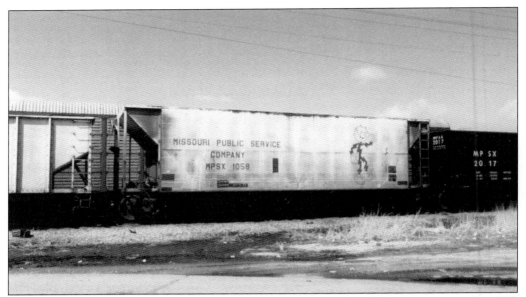

MPSX Covered Hopper No. 1058. Missouri Public Service (MPS) Company started in 1922 as the Green Light and Power Company. Later, according to the Henry County Library Tacnet Web site, it was renamed West Missouri Power Company. The company headquarters was located in Clinton, Missouri. Above, MPSX covered hopper No. 1058 is shown as part of a unit train at Central Industrial Drive in St. Louis. Below, MPSX covered hopper No. 1093 is shown as part of the same train. The lightbulb man, named Freddie Kilowatt, is the cartoon mascot that the company used on all of its railroad cars.

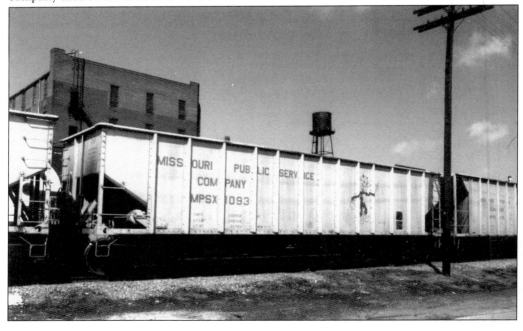

122

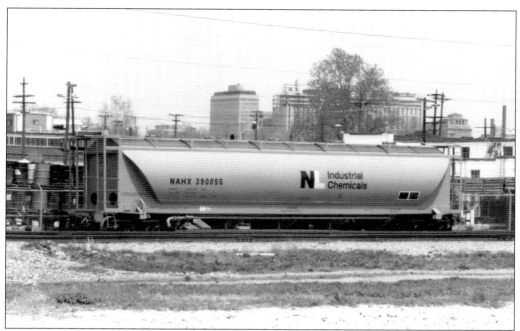

NAHX COVERED HOPPER NO. 390055. National Lead Industries, based in Houston, Texas, has been at the center of many lawsuits since the public health dangers associated with lead poisoning became known during the 1970s. It was a producer of lead paint. This covered hopper is on the Frisco siding of the National Lead Industries plant on Manchester Road in St. Louis on April 23, 1979.

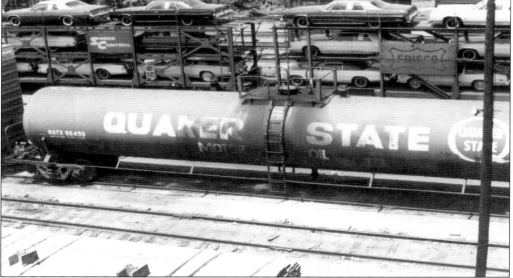

GATX TANK CAR NO. 86459. Quaker State started doing business when 19 similar companies combined in 1931. This single-dome tank car was leased from General American Transportation Corporation and carries GATX reporting marks even though it displays the lessee's company name on the car. It is viewed from the Arsenal Street Viaduct, parked in the Frisco Lindenwood yards of St. Louis on June 21, 1978.

AESX Tank Car No. 8643. A. E. Staley Manufacturing Company marketed corn products from its headquarters in Decatur, Illinois. The company leased this tank car from General Electric Rail Services Corporation, founded in 1975 by Jim Graves. During the time Graves worked for Mobil Oil, he managed railroad tank cars like this one, shown in September 1977, which may have carried corn syrup.

DODX/USAX Locomotive No. 8039. A trio of military engines led by No. 8039 is heading east near the LN yards of East St. Louis, Illinois, on May 30, 1974. Behind the train, the MacArthur Bridge and the Gateway Arch are visible. Both the U.S. Army and Air Force operate Department of Defense locomotives and railcars. Both branches utilized ALCO road switcher locomotives.

ACFX COVERED HOPPER NO. 26849. Stauffer Chemical Company leased both of these covered hoppers from the St. Charles–based ACF, Incorporated. Above, ACFX covered hopper No. 26849 is on the MP tracks at Central Industrial Drive in St. Louis in April 1978. Below, ACFX covered hopper No. 60740, an air-slide hopper, is at Central Industrial Drive in St. Louis on July 3, 1979. The Chicago-based chemical company, known for producing baking powder, ammonium phosphate, and sulfuric acid, was permitted to post its name on the leased freight cars.

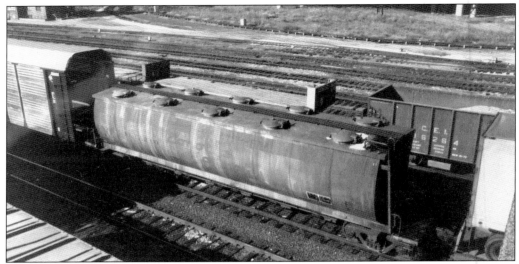

ZONOLITE BULK CARGO CAR. Zonolite was a brand of attic insulation that contained asbestos. The company was acquired by W. R. Grace and Company in 1963. This bulk cargo car was leased by W. R. Grace and Company from the Union Tank Car Company. Union Tank Car Company, based in Chicago, Illinois, had a fleet of 43,294 freight cars for lease. This one is shown from the Eighteenth Street Viaduct on the NW tracks in the Mill Creek Valley of St. Louis on October 18, 1978.

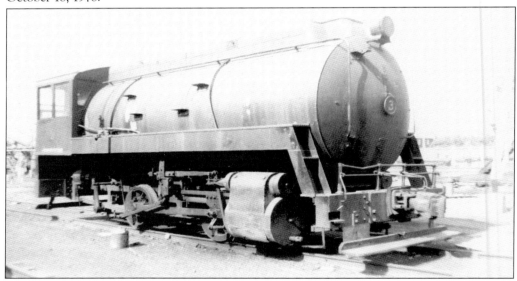

FIRELESS STEAM LOCOMOTIVE NO. 3. Union Electric Company operated the Ashley Street Power Plant located north of the Gateway Arch riverfront. Hoppers filled with coal arrived daily at the plant to boil water for steam to generate electricity. It was this Ashley Street Power Plant that generated the electricity to light the 1904 St. Louis World's Fair. Later the company began to build hydroelectric power plants, like the Taum Sauk Pumped Storage Plant, at locations farther from St. Louis. By 1977, according to William Faherty, Union Electric had 950,000 customers. Fireless steam locomotives do not generate their own steam. They do not need fire or water. Instead, they obtain steam directly from the power plant and operate until the steam is depleted, when they return to be refilled with steam. They are nicknamed "Thermos Bottles."

BIBLIOGRAPHY

Allen, M. *The Harnessed Channel: How the River Des Peres Became A Sewer*. www.cmsu.edu/co.
Colias, Joe G. *Frisco Power*. Crestwood, MO: MM Books, 1984.
———. *Mopac Power*. San Diego, CA: Howell-North Books, 1980.
———. *The Missouri Pacific Lines In Color*. Crestwood, MO: MM Books, 1993.
Dorin, Patrick C. *Missouri Pacific Lines Freight Train Services and Equipment*. Marceline, MO: TLC Publishing Incorporated, 2001.
Faherty, William Barnaby, SJ. *The Saint Louis Portrait*. Tulsa, OK: Continental Heritage, Incorporated, 1978.
Pinkepank, Jerry A. *The Second Diesel Spotter's Guide*. Milwaukee, WI: Kalmbach Publishing Company, 1973.
Quiz On Railroads and Railroading. Washington, DC: Association of American Railroads, 1966.
Railroads Unlimited! America's Modern Transportation Miracle. Washington, DC: Association of American Railroads.
Rand McNally and Company. *Rand McNally Handy Railroad Atlas of the United States, Railroad Model Craftsman Edition*. Fredon, NJ: Model Craftsman Publishing Corporation, 1973.
Szwajkart, John. *Train Watcher's Guide to St. Louis*. Brookfield, IL: 1983.
———. *Train Watcher's Map of St. Louis*. Brookfield, IL: 1983.
Wayman, Norbury L. *St. Louis Union Station And Its Railroads*. St. Louis, MO: The Evelyn E. Newman Group, 1987.
Wilner, Frank N. *Railroad Mergers: History Analysis Insight*. Omaha, NE: Simmons-Boardman Books Incorporated, 1997.
Zellich, Rich. *All Time Diesel Roster of the TRRA*. www.trra.railfan.net/roster.html, 2000.

Discover Thousands of Local History Books
Featuring Millions of Vintage Images

Arcadia Publishing, the leading local history publisher in the United States, is committed to making history accessible and meaningful through publishing books that celebrate and preserve the heritage of America's people and places.

Find more books like this at
www.arcadiapublishing.com

Search for your hometown history, your old stomping grounds, and even your favorite sports team.

Consistent with our mission to preserve history on a local level, this book was printed in South Carolina on American-made paper and manufactured entirely in the United States. Products carrying the accredited Forest Stewardship Council (FSC) label are printed on 100 percent FSC-certified paper.